50 GEMS
Mid Wales

GEOFF BROOKES

AMBERLEY

To our children, Laura, Catherine, Jennie and David

Such Wonders to Behold –
Original artwork in clay by
Jason O'Brien. (Photograph
by Alan Bromage, with kind
permission)

First published 2018

Amberley Publishing
The Hill, Stroud
Gloucestershire, GL5 4EP

www.amberley-books.com

Copyright © Geoff Brookes, 2018

Map contains Ordnance Survey data © Crown copyright and database right [2018]

The right of Geoff Brookes to be identified as the Author
of this work has been asserted in accordance with the
Copyrights, Designs and Patents Act 1988.

British Library Cataloguing in Publication Data.
A catalogue record for this book is available from the British Library.

ISBN 978 1 4456 6824 6 (paperback)
ISBN 978 1 4456 6825 3 (ebook)

Map illustration by User Design, Illustration and Typesetting.

Origination by Amberley Publishing.

Printed in Great Britain.

Contents

Introduction

Mid Wales is always beautiful and always fascinating. Ceredigion and Powys are at the centre of Welsh history and at the heart of its language and culture, which has made this book a great pleasure to write, for I have learned a huge amount about a remarkable and varied area. There are so many peaceful places where you can connect with a world that seems not to have changed and yet in the past armies frequently marched across this magnificent landscape.

There is so much here to see and to enjoy. You may not agree with my selected 'Gems', and there were certainly some difficult choices to make. I have tried to select places that I think you would like to see, places that will interest and inspire you and give you an opportunity to connect with the past and to enjoy the present.

There is a popular boast that God first created Wales and then built the rest of the world with the leftovers. There are places in Mid Wales where you might just start to think this to be true.

The author and the publisher would like to thank the following people and organisations for permission to use their images in this book. I am very grateful indeed for the invaluable support I have received from them all: Jason O'Brien, Kiran Ridley, Chris Newman, Hugh Lester, Scott Lewis, Timothy Soar, Royal Welsh Agricultural Show, The National Show Caves, The National Library of Wales, J. R. Jones and the Vale of Rheidol Railway, The Centre for Alternative Technology, The Judge's Lodging, The Ceredigion Museum, and Gregynog Hall.

I am also very grateful to Norma Olds for her help with the astonishing Cascob Charm and to Mary Oldham at Gregynog Hall for her expert help and guidance.

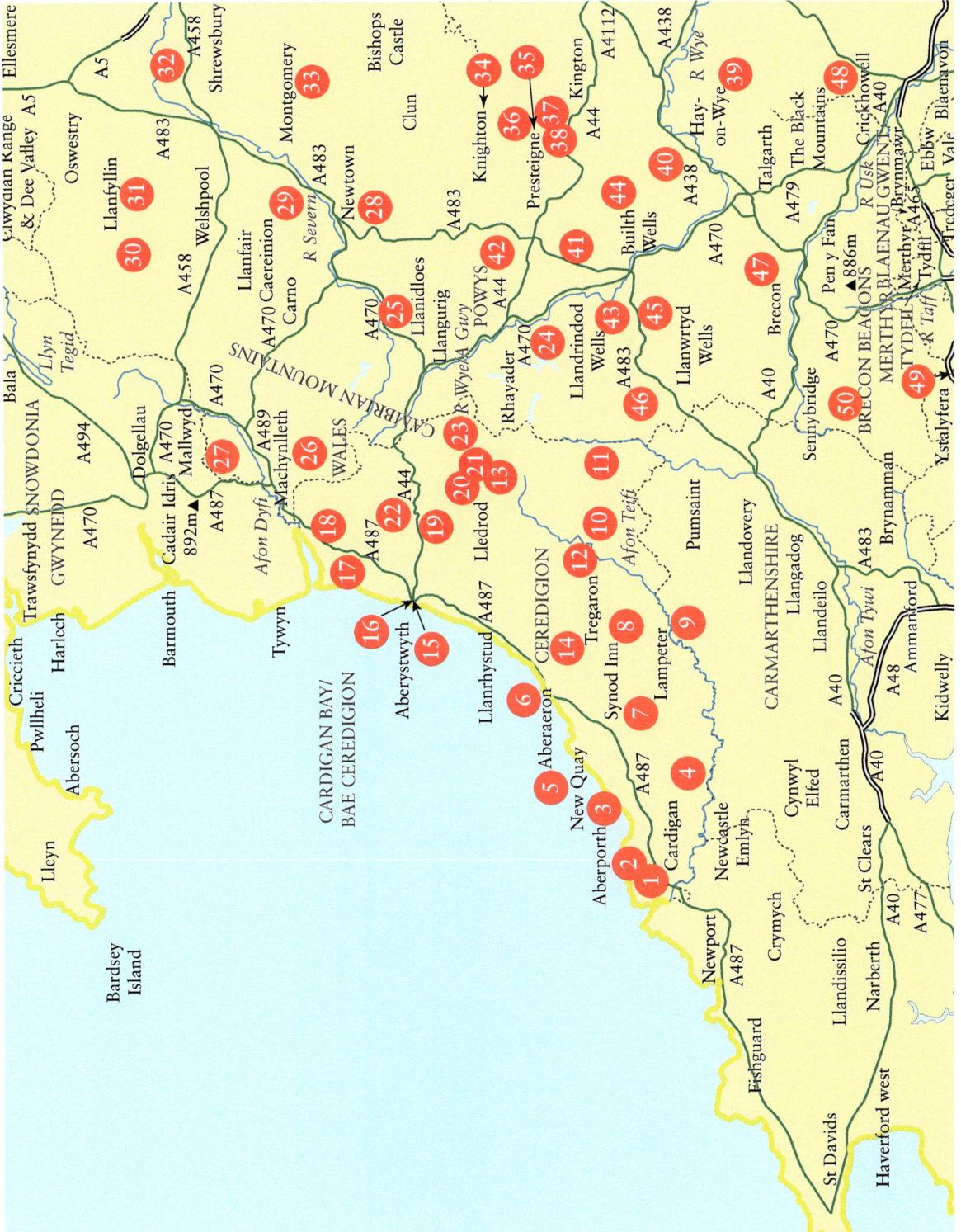

Welcome to Ceredigion

1. Cardigan

Faith and War

At the lowest bridging point of the Teifi and on the river's northern bank you will find the neat attractive town of Cardigan, once the county town of Cardiganshire. It was originally a small walled town gathered around the castle, which has an important place in the Welsh consciousness as the home of the first national eisteddfod in 1176. In 1860 the writer John Tillotson said that the castle with 'its crumbling walls overgrown with ivy is a fine subject for an artist's pencil' and it still retains that picturesque quality. It is now owned privately and offers a restaurant and stylish accommodation along with numerous seasonal attractions.

The main street, which climbs up from the restored five-arched medieval bridge over the river, has pleasant shops and cafes. Halfway along there is the Guildhall, the site of an interesting craft market. Outside you will find a fine Crimean cannon upon which children can frolic. It is a pleasant place to wander around, with narrow streets and pretty cottages.

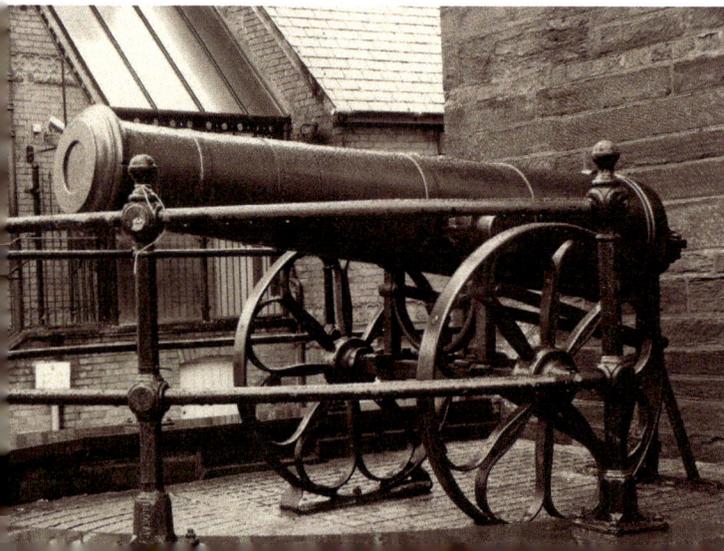

Crimean cannon. (Author's collection)

Cardigan has a long history as a busy port. In the early nineteenth century it was the most important seaport in South Wales but its significance diminished as the river silted up.

But it wasn't always ships that found their way up the river.

On Priory Street you can find St Mary's, once the priory church for a Benedictine community and famous throughout Wales for an image of the Virgin and her Miraculous Taper.

In medieval times a statue of Our Lady and Child was washed onto the banks of the Teifi with a burning candle in her hand. It caused quite a stir, as you can imagine, but every time they moved the statue to their parish church it would suddenly reappear back by the river. Consequently St Mary's was built to accommodate this strong-willed statue. It became an important pilgrimage destination, giving supplicants comfort, hope and unshakable faith in waterproof candles. However the statue was removed during the Reformation and taken to London, where it was destroyed in 1538.

In 1952 a new statue was carved in wood, based upon descriptions of the original, and a new shrine was consecrated for it – Our Lady of the Taper – the Catholic national shrine of Wales, which is to be found at the north of the main street, opposite the rugby field, which for some is also a kind of shrine.

Sadly the wooden version didn't wear well and in 1986 it was recast in bronze by the sculptor and Benedictine nun Sister Concordia Scott with a candle blessed by Pope John Paul II in Rome in her hand.

After such high-profile intervention I am pleased to report that the statue has remained stationary – well, apart from when it was taken up to London in 2010 to be blessed by Pope Benedict. It is tough work being an icon.

Postcode SA43 1JA will take you to Cardigan Castle.

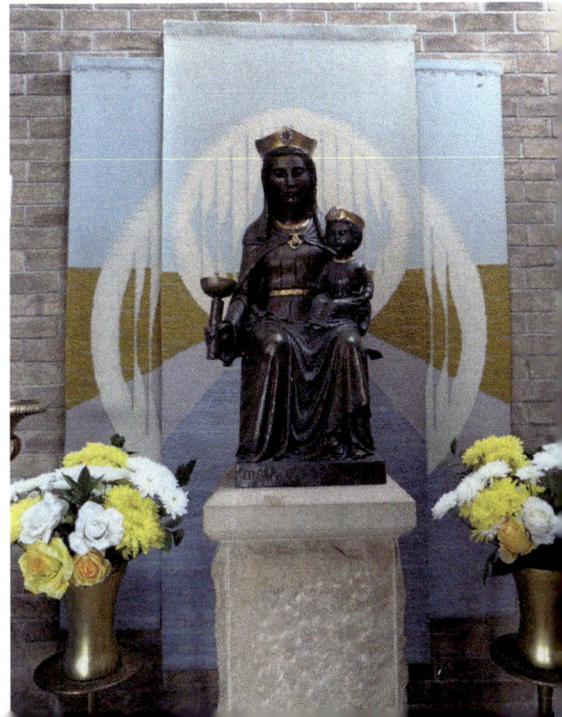

Our Lady of the Taper. (Author's collection)

2. Mwnt

Bones on the Beach

Mwnt is 4 miles east of Cardigan. A narrow country road leads to a car park on the clifftop above the horseshoe bay with 139 steps leading down to the perfect secluded beach.

Above the beach there is the delightfully simple fourteenth-century Church of the Holy Cross and there are stories of an unsuccessful 'invasion' by Flemings when the coast of Flanders was inundated in 1155 and they looked desperately for new land. Perhaps their intentions were peaceful but the Welsh were not accommodating. 'The invaders were defeated with dreadful carnage, and their dead bodies were strewn in heaps on the sands.' (Samuel Lewis, 1833)

For centuries victory was always celebrated by anniversary games on the beach known as 'Sul Coch y Mwnt' involving 'wrestling and kicking football' – a bit like rugby I imagine, but with simpler rules. There are also reports of those bones revealing themselves after storms. It is hard to believe that it happened here.

Mwnt is an astonishingly attractive place. To be honest I don't think we should mention it to anyone else. Let it be our little secret.

The postcode you need is SA43 1QF.

Down to the beach at Mwnt. (Author's collection)

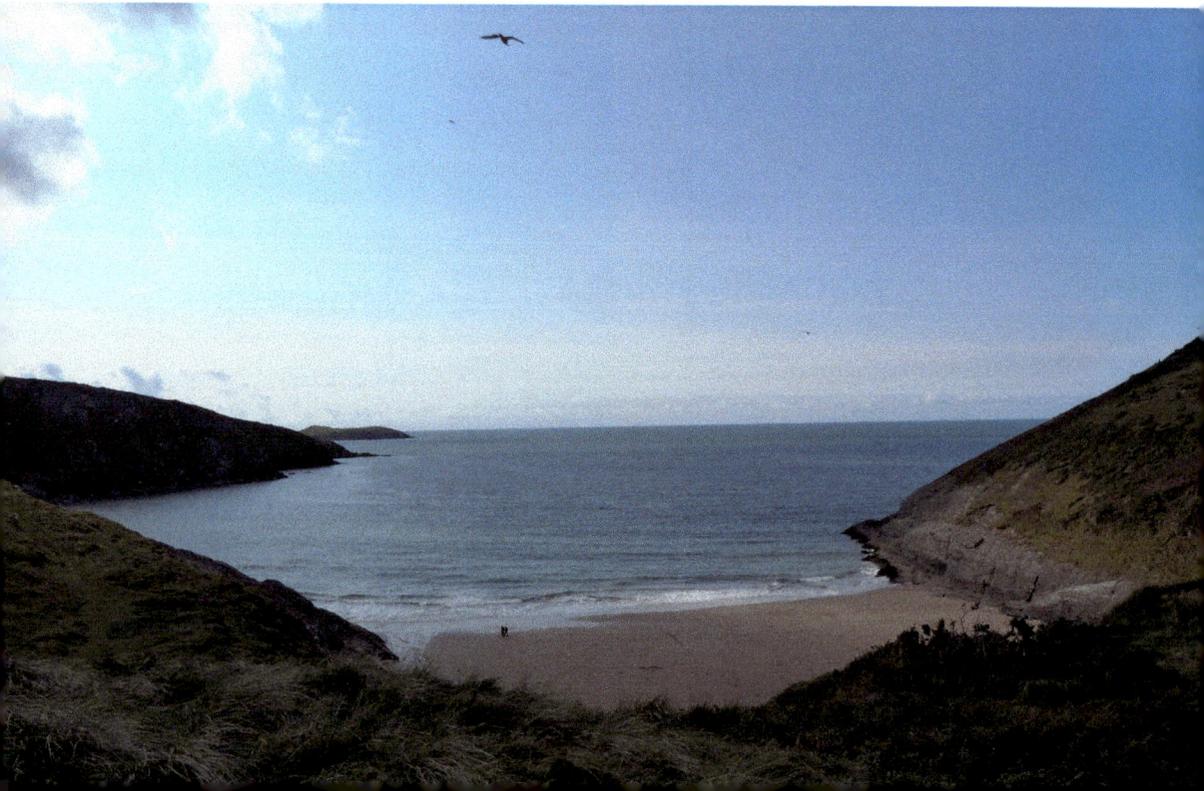

3. Llangrannog

Treasures from the Sea

Llangrannog is a tranquil place, squeezed along the deep narrow valley where the River Hawen falls into the sea. For some this is the most attractive village along Cardigan Bay.

The tight streets run down towards the pleasant, very popular beach where there is one of the most photographed pieces of rock in West Wales, called Carreg Bica – a large fractured stack on the beach, apparently the tooth of the giant Bica who spat it out during a painful dental crisis. Perhaps he should have visited St Mary's Well in the village and taken solace from its healing properties.

Like everywhere in Ceredigion the village has a long history. It was established around the church, discreetly hidden from Viking view, and its life has always been based on the sea – and economic reality. In the eighteenth century salt smuggling was more lucrative than farming. Salt was brought in cheaply from Ireland to preserve bacon and herring but smugglers also found time to import wines and spirits to exploit the impressive storage facilities provided by local caves. Today tourism is the only industry and discerning visitors are well cared for.

Many young people know Llangrannog very well because the Welsh League of Youth (the Urdd) has an important holiday centre at Pigeonsford at the entrance to the village, and every year it accommodates young people from across Wales who enjoy bracing activity holidays.

The church is dedicated to Saint Caranog and there is a splendid statue of him on the headland above the beach, clearly enjoying the view of the village. It was designed by Sebastien Boyesen and is definitely worth the steep walk up the hill. You should also find time to visit the memorial in the churchyard to a remarkable woman, Sarah Jane Rees (1839–1916).

Sarah's father navigated a small boat around Cardigan Bay and Sarah's childhood ambition was to emulate him. After nautical school in London she qualified as a sea captain and navigator, the first British woman to do so. She became a teacher of basic literacy and numeracy to farm boys in the day and then advanced navigation to sea captains in the evening, frequently working in kitchens and barns in local farms. She was a prominent figure in the Welsh Temperance Union and was twice awarded the chair for poetry at the National Eisteddfod, where she used a bardic name in homage to the village that made her – Cranogwen.

Llangrannog is between New Quay and Cardigan, down a steep hill from the A487. The postcode is SA44 6AE.

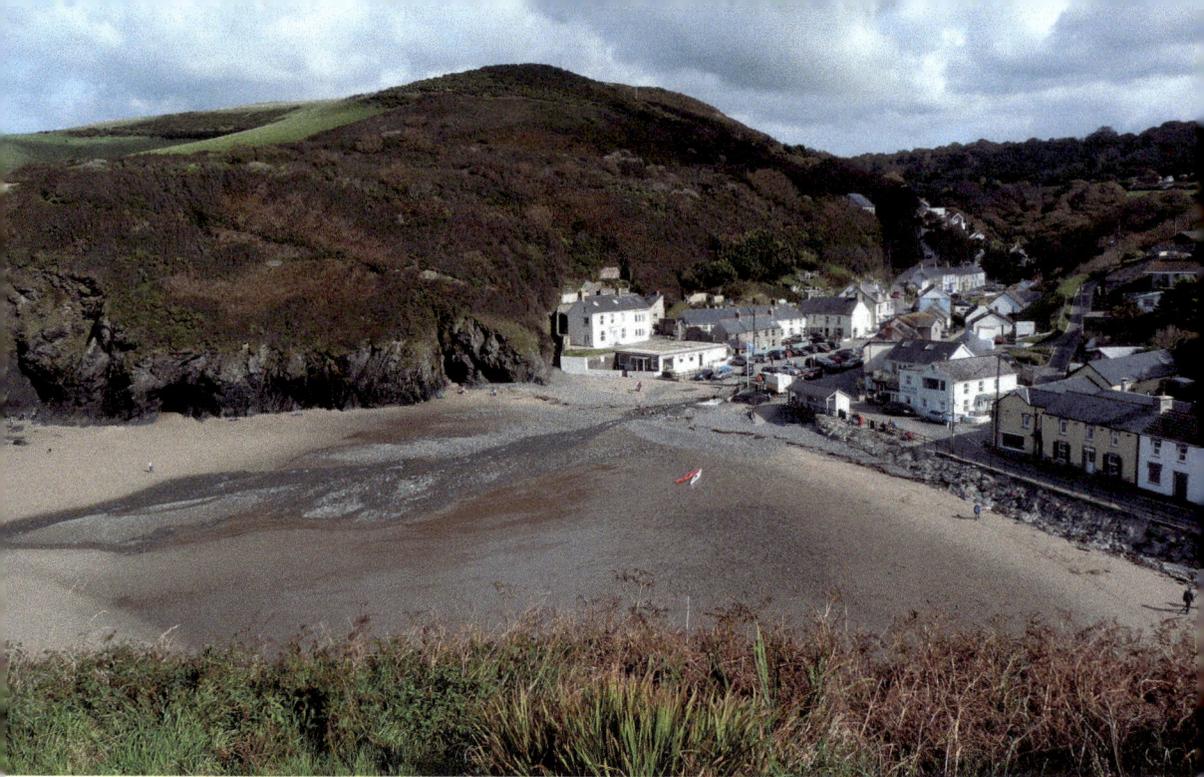

Above: Llangrannog at low tide. (Author's collection)

Below: Caranog, by Sebastian Boyesen. (Author's collection)

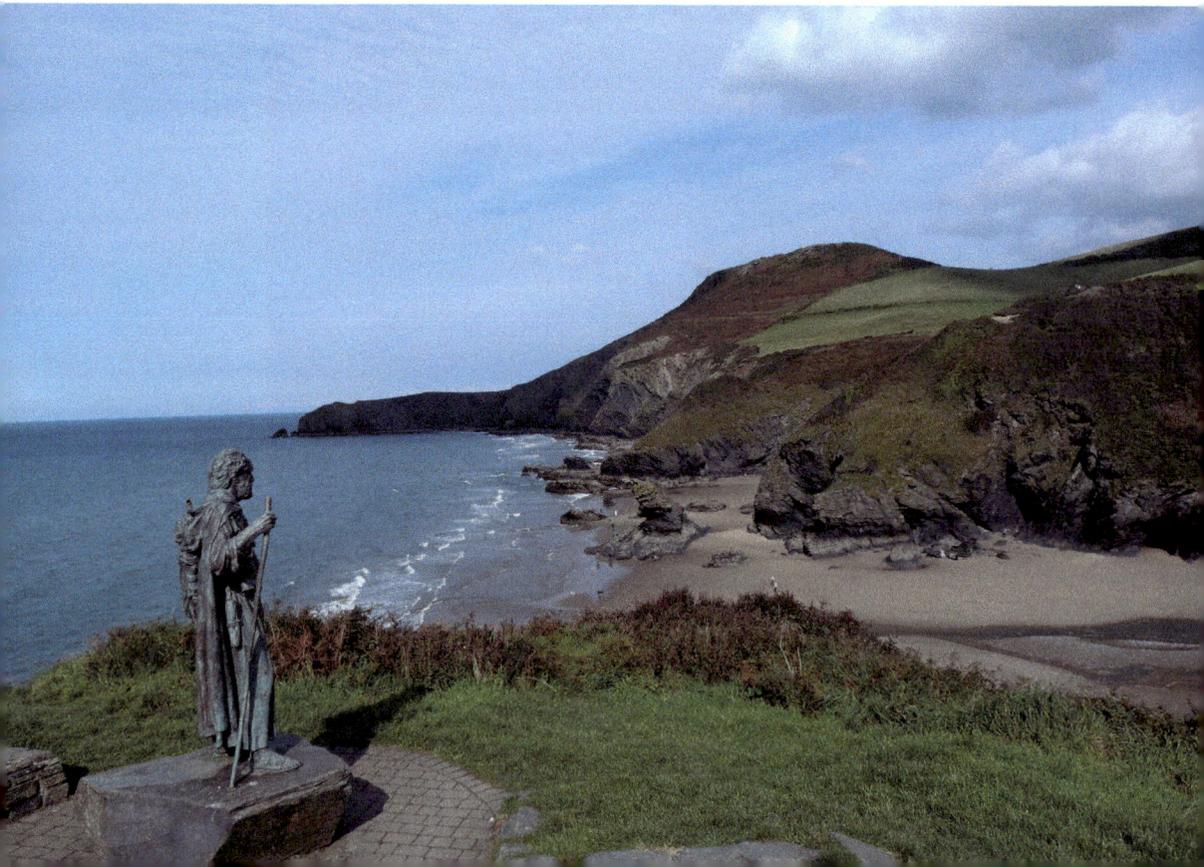

4. Caws Teifi

Amongst Happy Cows

If you like proper cheese then you will love Caws Teifi. They produce some of the most highly regarded cheeses in the country.

It was started by John Savage-Onstwedder, who moved to Ceredigion from the Netherlands in 1981 with a background in organic farming and began to make cheese to a Gouda recipe. They now produce a range of cheeses all from raw unpasteurised cow's milk. In fact during production the milk is not heated above 37 degrees – the body temperature of a cow, and therefore the temperature of milk in the udder – which ensures a more natural and more complex flavour. Quality milk makes quality cheese. The process begins in traditional teak vats, not metal ones, with the addition of vegetarian rennet, which causes the milk to separate into curds and whey. Reliable nineteenth-century mechanical presses extract the whey slowly (which goes off to a local pig farmer) and in the end 1,200 litres of milk produces 150 kilograms of cheese.

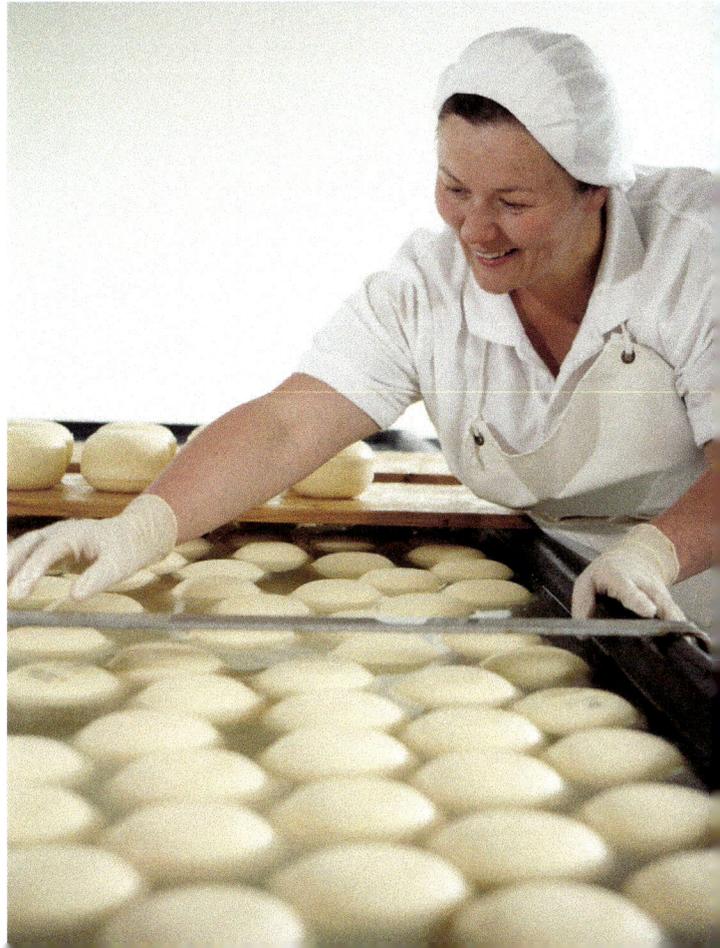

At Caws Teifi. (Photograph by kind permission of Kiran Ridley)

It is a very labour-intensive activity in which precision creates cheeses with very different attributes. As well as the Teifi, a young and mature Caerphilly is produced and some of the most popular cheeses have additional flavourings like nettles and seaweed. It might sound like a modern affectation but the practice has a long tradition: in the past Caerphilly cheese often included sage and the Dutch have been adding cumin seeds to their cheese for centuries.

There has been further diversification at the farm with the creation of a distillery which produces gin whisky and an orange liqueur.

What they achieve here is a marriage between traditional skills on the farm and the knowledge needed to maintain an engaging website and a successful digital presence. It is still hard work but this must be the best way that Ceredigion can engage with the rest of the world.

Lots of artisans come to West Wales to build a new life based upon their own creative and practical skills. Not everyone is as successful as Caws Teifi but it remains a seductive dream. It isn't easy but this doesn't appear to discourage the potters and the candle makers desperate to embrace a rural lifestyle. Many don't manage to make it work but the skilled workers of Caws Teifi do and they continue to successfully market a taste of the fields of Wales to the world.

Glynhynod Farm is north of Llandyssul down narrow lanes signposted from the A486. The postcode is SA44 5JY.

They do tours. They would love to see you.

Photograph by kind permission of Kiran Ridley.

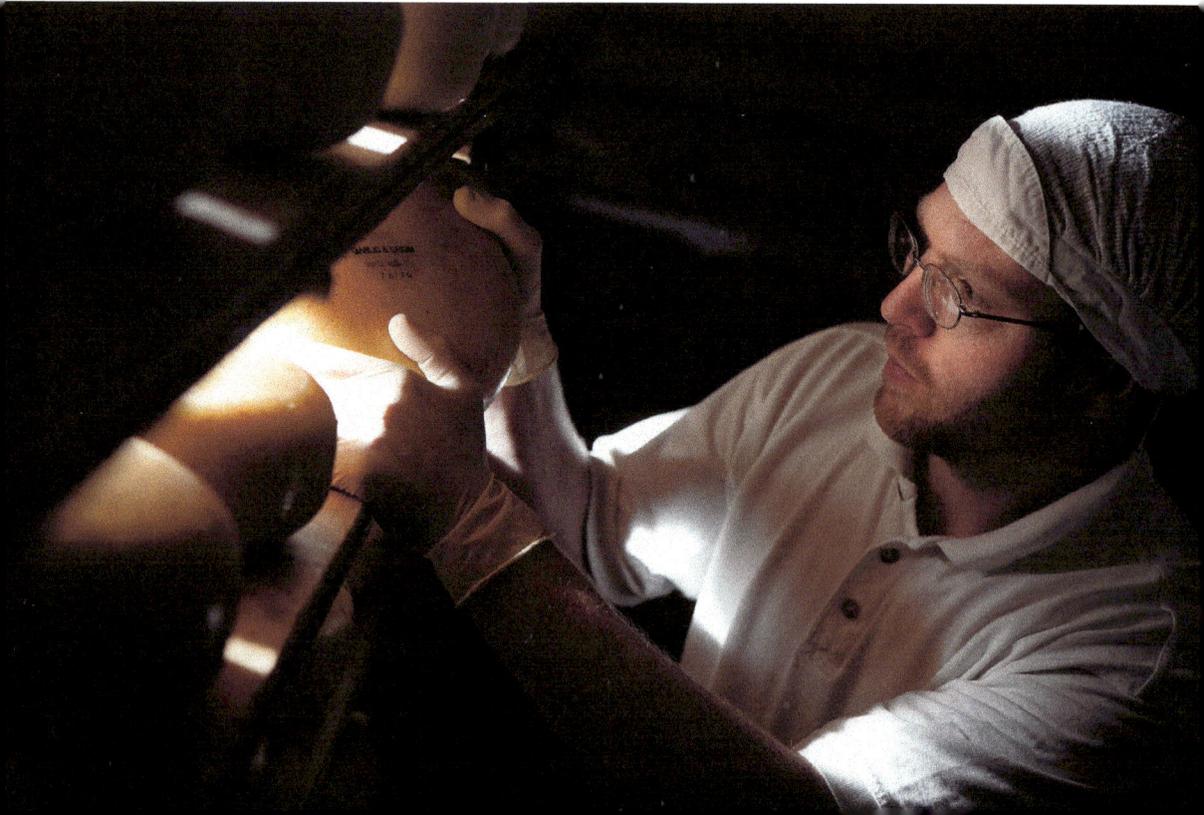

5. New Quay

Bottlenose Dolphins and Writer

This attractive town spreads over the hillside above a small curving beach. The stone harbour now offers shelter for leisure craft and provides scenic interest for so many holiday photographs. After all, New Quay is a tourist destination, a popular resort offering traditional attractions. It is hard to believe that it was once quite a different place. In the eighteenth century it was a notorious smuggling base, with a lucrative trade in contraband salt, as well as the home of an important herring fleet. In the nineteenth century New Quay was a busy port with thriving shipbuilding yards which supported a range of other service industries like ropemakers and blacksmiths. It was a place to which sea captains retired to enjoy tumbling streets and attractive terraces and it soon began to attract people who also wanted to enjoy its unsophisticated charm. In 1905 it was described as a 'charming little place situated 23 miles from civilisation', which might indeed be the reason some people return year after year.

The harbour at New Quay. (Author's collection)

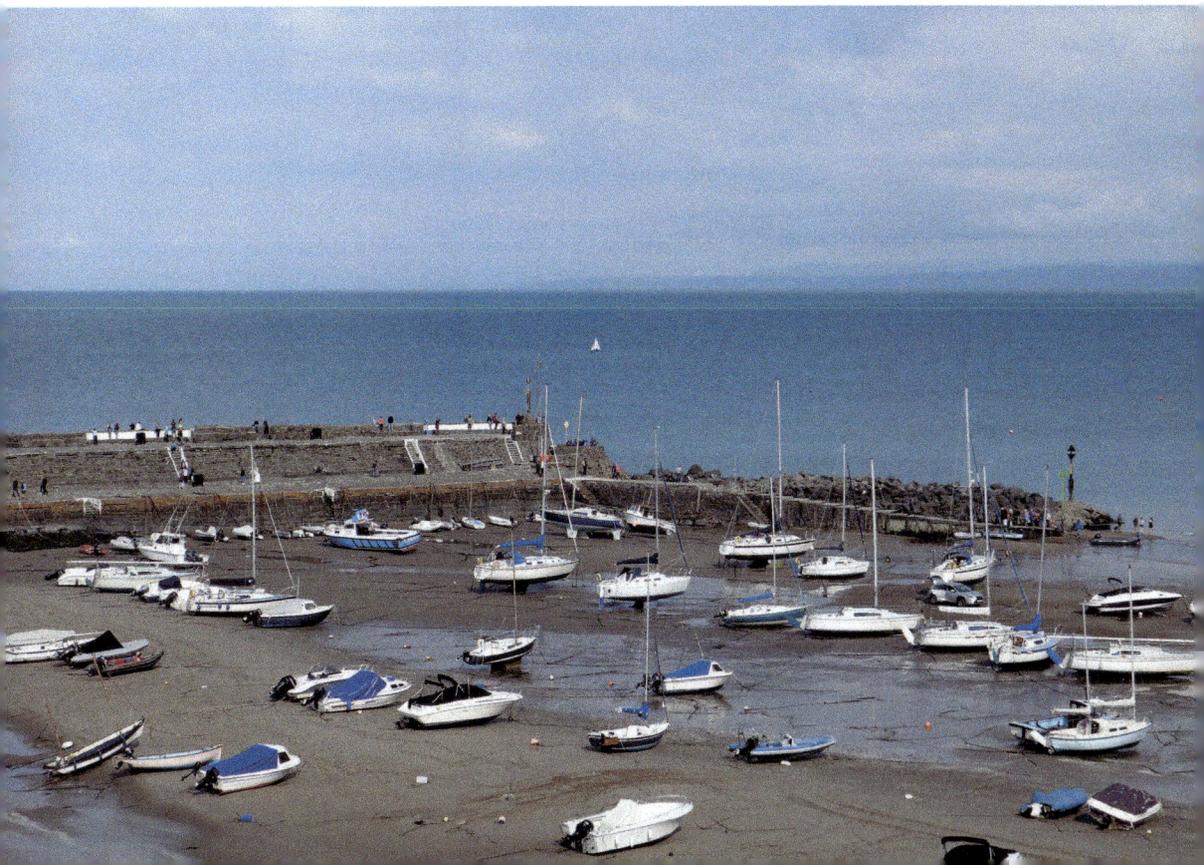

The economy is now based upon tourism and New Quay is surrounded by popular caravan parks offering a self-catering retreat with pleasing sea views. You can go fishing or take a boat trip to spot the bottlenose dolphins following the shoals of mackerel into the bay – though this is not what drew Dylan Thomas here in 1944. He came to New Quay to escape the war and to write in peace in a rented bungalow. However, he was regarded with some suspicion by the locals. Not only did he use a pram to take his beer home and hide in the toilet when the landlord came to call, but also he was argumentative and unpredictable. He wrote, 'It is lovely here. I am not.' When he argued with a drunken neighbour who then fired shots with a machine gun at the bungalow, the Thomas family quickly moved on.

However, Dylan Thomas seems to have used New Quay as part of his inspiration for *Under Milk Wood* and today there is a Dylan Trail around the town, which will take you to places that may feature in the work, although Laugharne in Carmarthenshire also claims to be the inspiration for the fictional setting of Llareggub. But when you are here you will believe in New Quay. Until, of course, you go to Laugharne…

However, it does seem perverse that two small towns should argue about which one of them deserves to be called 'Bugger All' backwards.

The postcode you need is SA45 9PT.

New Quay houses facing out to sea. (Author's collection)

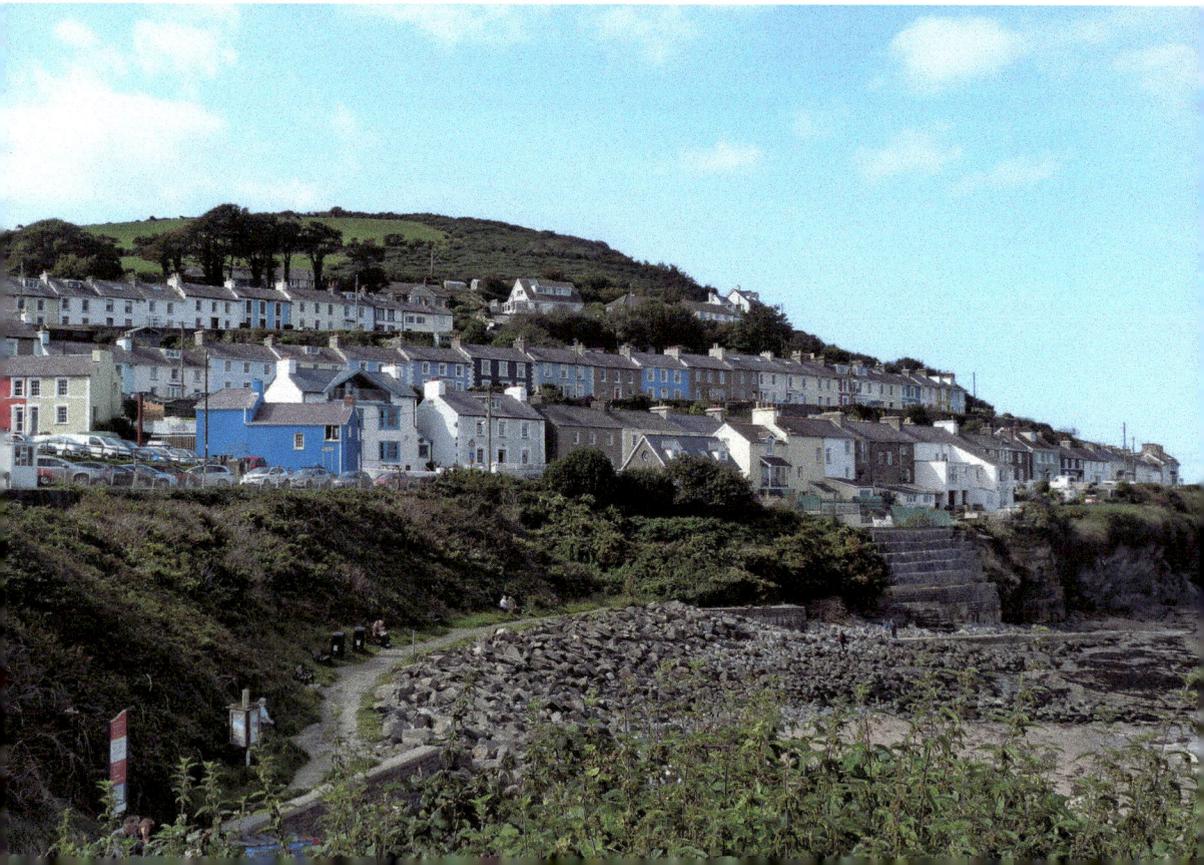

6. Aberaeron

Proper Seaside

Aberaeron is a vibrant and elegant town and it is always a good one to visit, even if the beach is only suitable for particularly avid collectors of pebbles and stones. Aberaeron has good cafes and restaurants, nice pubs, and craft and art galleries. It is a place to come for a proper seaside experience – fish and chips and ice cream. There is a farmers' market on Wednesdays and in July it is the venue of the Cardigan Bay Seafood Festival. There are pleasant walks along the coast and the river valley.

The town was created in the nineteenth century. The Revd Alban Thomas-Jones Gwynne, a country rector from Hampshire, inherited the Mynachty Estate and in 1807, with admirable entrepreneurial zeal, developed the harbour, diligently working his way through his wife's inheritance. The existing small herring fishing fleet was soon augmented by a flourishing shipbuilding industry providing valuable employment. At one time there were thirty-five pubs serving the needs of a traditionally thirsty workforce. With the expansion of the harbour, local industry expanded too. Later the Revd Alban's son, Colonel Gwynne, employed Edward Haycock, an architect from Shrewsbury, to build the town as we now see it, with an attractive unity of design.

An important claim to fame is that in a local forge they used to make the Aberaeron shovel. The triangular blade and long, curved handle were apparently designed to reduce backache amongst diggers. In other parts of the country the design was called the 'lazy back shovel'.

In 1880 it had a hand-powered cable car stretching across the harbour, replacing the bridge when it was washed away in a flood. It was called 'The Aeron Express' and was revived in 1988, running as a tourist attraction until 1994, though harbour traffic sometimes got in the way. Not surprisingly, the new bridge was considered more efficient. All that now remains of the Express is the landing platform.

In 1879 Dr Burghardt from Manchester found a mineral spring and suddenly Aberaeron felt fortunate to be 'blessed with an exceptional natural boon'. Analysis showed a reassuring 'absence of organic matter and poisonous metals' in the water; a boost to tourism was anticipated. It would be highly beneficial in cases of 'deficiency of the red corpuscles of the blood' and for 'weakly children or those recovering from a long illness'. A circular stone building on Chalybeate Street still marks the site. The spring was concreted over some years ago.

Aberaeron is between Cardigan and Aberystwyth on the A487 at the junction with the A482 from Lampeter. The postcode you need is SA46 0AS.

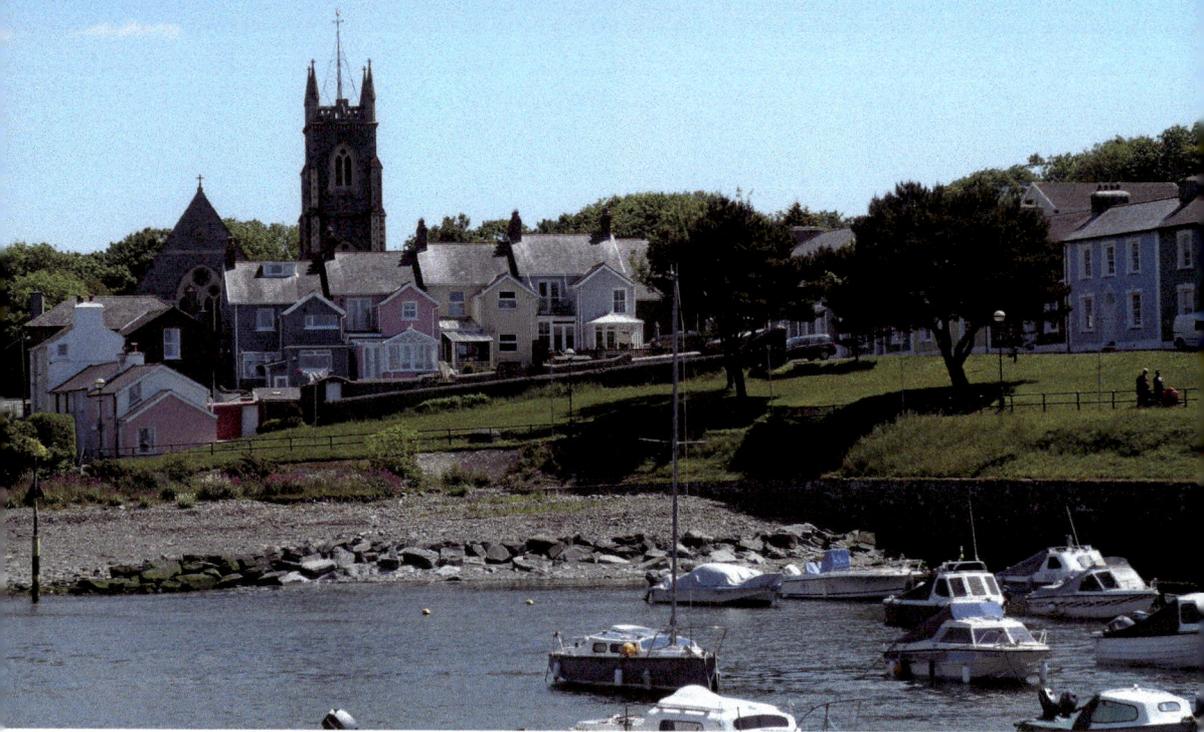

7. Cae Hir Gardens

A Living Canvas

We love Cae Hir Gardens. How could you not? It is a wonderful place, always showing you something new, a vibrant and varied garden created within a beautiful setting, which brings a welcome European dimension to the green of West Wales.

Wil Akkermans, a French teacher in Holland, met Gillian Davies while on holiday in Aberystwyth in 1974. They married and eventually returned to Wales to establish their own garden at Cae Hir in 1983.

It was previously a smallholding with a small number of cows. Outbuildings had been a workshop for a coffin maker. The land was uncultivated rough pasture and the transformation was carried out by hand. Hedgerows were removed and walls constructed as the framework for a carefully conceived plan. It took six years to construct the gardens and opened in 1989. Now it should be regarded as a living piece of art.

Cae Hir Gardens. (Author's collection)

The gardens are a place of carefully considered beauty, the vision of one man, a magical garden forged in a Dutch imagination with a view at every turn. There is a winding stream, a water garden, a bonsai garden, a bog garden and a rose garden, all brought together in one artistic whole. The garden is now recognised as one of the Royal Horticultural Society's Partner Gardens.

Cae Hir requires constant maintenance. All gardeners are in constant conflict with subversive elements of nature as they try to sustain the integrity of their creation – dandelions, honey fungus, and rabbits forever lie in wait.

This garden was the creation of one man working alone, with traditional hand tools and with no external financial support. It is a fantastic achievement. Will Akkerman said, 'Every plant, every stone, has passed through my hands.' Visitors will be forever grateful for that astonishing dedication.

The garden is open from April to the end of October. Appropriate footwear is essential for West Wales is wet – which is what makes it so wonderfully green – and it is steep in parts, which creates perspective. There are few paths; much is vibrant green lawn, so nice to walk upon.

There is a good Garden Tea Room. Cae Hir hosts activities such as Plant Days and it is also the venue for the Outdoor Quilt Exhibition in August, which transforms the garden into a gallery with vibrant patterned quilts hanging from trees. The overall effect is exceptional.

At Temple Bar on the A482 road between Lampeter and Aberaeron, take the B4337 towards Llanybydder. You will find the gardens at Cribyn. The postcode is SA48 7NG.

Shades of green in Cae Hir. (Author's collection)

8. Betws Bledrws

Long Tom

When you are driving around south Ceredigion the Derry Ormond Tower is something that is very difficult to avoid. It stands on a hill dominating the views around Betws Bledrws near Lampeter, a nineteenth-century folly and yet one that was erected with the very best of intentions.

To be honest, it is a very strange thing. It is believed to have been completed in around 1824 by John Jones from the local Derry Ormond Estate, a substantial property of over 15,000 acres which, like so many others, faded away until the mansion at its heart was demolished in 1952.

Children were told that it was built so that Jones could spy on his wife while she was shopping in London. On other days they were told it existed to watch for the safe return of ships in the Bristol Channel. My, how those children must have laughed.

A more plausible explanation, though in some ways no less bizarre, is that it was merely a way of providing work for the local unemployed. Local men, wrestling with grinding rural poverty, were paid to carry out the entirely pointless task of building a large tower almost 40 metres tall on common land

Long Tom. (Author's collection)

to replicate the upturned barrel of a cannon, allegedly Long Tom, used at the Battle of Waterloo.

No one wrote anything down about the construction of such a distinctive landmark. It was probably designed by the architect Charles Cockerell, who had designed St David's College in Lampeter. The builder was David Morgan of Llanddewi Brefi – we know this because it is so proudly proclaimed on his gravestone.

There is a great irony of course. The building of the tower might have offered short-term relief for the unemployed but the expense seriously compromised the financial security of the estate itself. Today, in what is possibly terminal irreversible decay, it represents another time. It shows the squire doing his bit for the local poor, letting them construct something to reflect his own small-town importance. But it has been poorly maintained and has lost much of the brief celebrity it once had.

It might have been renovated and stabilised in the 1970s by the Royal Monmouthshire Engineers but stands now in considerable distress. The entrance has been bricked up, with only a small hole allowing access to the ground floor. The staircase to the top of the tower is seriously unsafe.

Betws Bledrws is north of Lampeter on the A485 and you will certainly be able to see it. Use postcode SA48 8PA.

9. Lampeter

The Benefits of a Good Education

Sir Herbert Lloyd, MP for Cardigan, was a man who left his mark on this pleasant town as 'the most feared and despicable of all country squires'. In 1763 he was in a dispute over a local field with Sion Philips. Lloyd claimed that a valuable black ram had been stolen from his flock while at the same time secretly arranging for it to be lowered down Sion's chimney. He was then arrested, sentenced to death and executed for sheep-stealing and Lloyd took possession of the field … And him a graduate of Jesus College Oxford too.

Today Lampeter now hosts part of the University of Wales Trinity St David's, which adds spirit and atmosphere to the town. A college was founded here in 1823 for the education of the clergy to save Welsh parents the expense of sending their sons to Oxford or Cambridge – and presumably to stop them turning out like Herbert Lloyd. As a concession, the central building was built like an Oxbridge quadrangle. It transformed what was a small and straggly market town with a single cobbled street often decorated with dung heaps and other offensive material and noted for fights, drunkenness and blasphemy. Clearly it was a university town long before it had a university. Postcode SA48 7ED will take you there.

10. Llanddewi Brefi

Bullish

Llanddewi Brefi still draws people who wish to be photographed by the sign at the entrance to the village – as long as it hasn't been stolen again. It is all because of the use of its name in popular television comedy series *Little Britain*, which has bemused and annoyed residents in equal measure. Hopefully it doesn't distract too much from other aspects of its history.

Llanddewi Brefi is at the foothills of the Cambrian Mountains between Lampeter and Tregaron, close to the A485, and the attractive village with a pleasant collection of cottages reaches out into the valleys which converge here.

Llanddewi Brefi dates back not only to Roman times (there are the ruins of the Roman fort Bremia and a bathhouse nearby) but also to a time, should you chose to believe it, of magical happenings.

It has always been a site of religious significance and St David attended a synod here in 519 – perhaps in order to debate the Pelagian heresy (I think we

Above: St David's Church, Llanddewi Brefi. (Author's collection)

Left: All that remains of the Foelallt Arms in Llanddewi Brefi. (Author's collection)

should leave that for another day) – and there a miracle occurred. The saint made the ground rise beneath his feet so that he was lifted above his unruly audience, who were struggling to hear his speech. This is a pretty good trick if you can pull it off and especially useful at a range of sporting fixtures or music festivals. This swelling became the site of St David's Church, which does indeed stand on a mound. And if that is not enough, then you need to think about oxen.

'Brefi' is the name of the river which runs through the village and might mean 'bellowing'. This could refer to a poor ox killed by the considerable effort of dragging church stones up the mound St David created. A companion ox bellowed out in sorrow nine times and a level track is said to have appeared before it. Again, this is another useful trick worth mastering. Of course it could merely refer to the roaring of the stream, but I always prefer to employ a spot of imagination in these matters.

We might regard it as a quiet village now but be aware that in 1977 Llanddewi Brefi was the scene of one of the biggest ever raids involving the drug LSD when over 6 million tablets of it were seized. If these were the remains of a stash left behind by St David following his visit in 519, then it might go some way to explaining that clever trick with the ground.

The postcode is SY25 6PE.

11. Soar-y-Mynydd

Into the Green Desert

Soar-y-Mynydd is the most iconic chapel in Wales. It stands almost lost in the hills on the west side of Llyn Brianne. You should drive along a single track road from Tregaron, deep into what is called the green desert of Wales. You will not see many people, just sheep and kites. On the way you will find an isolated phone box at a crossroads called Cefn Cerrig, which has a similarly legendary status as the place you are seeking; the most remote of all the chapels in Wales.

The chapel was built in 1822 by Revd Ebenezer Richard, the father of Henry Richard of Tregaron (see entry), to serve the farmers who lived out there and for the drovers who passed through. It has a simple uncomplicated design and is made of local stone collected from riverbeds and ruined farmsteads. Timber and slates came from North Wales via Aberaeron 20 miles away. The building has been whitewashed, which makes it stand out amongst all the green.

They called it Soar-y-Mynydd ('Soar on the Mountain'), named after Zoar – where Lot sought sanctuary after fleeing from Sodom. It therefore represents a place of refuge. This is what it was for the scattered community too, though that might seem to be an unfair slur on the rest of Wales.

Local farmers would collect preachers on horseback from Tregaron or Llanddewi Brefi and offer overnight hospitality. When there was still a small community a teacher would spend the week here and work in the schoolroom. No one lives here anymore, though it is still used occasionally – sometimes as a trendy wedding venue.

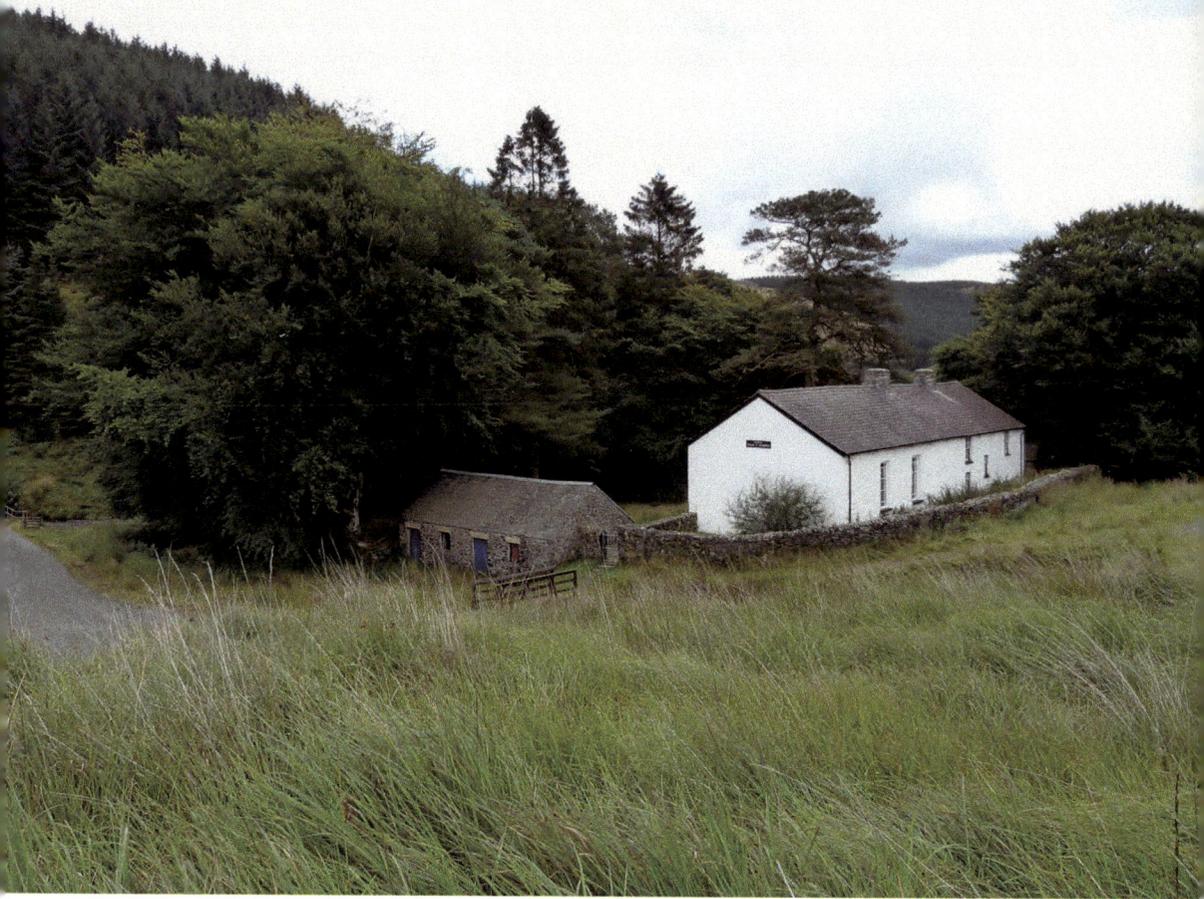

The building is usually open, though there is still no heating or electricity. Inside a chair remembers John Hughes Williams, who worked hard to keep the chapel open and was murdered during a burglary at his home in 1983, a horrifying crime for an area travelled to as a part of a pilgrimage for people in search of isolation to bring them closer to their faith. In his poem 'Above Tregaron' Harri Webb writes,

> The loneliest it is said, even in this land
> Of lonely places, and on the high ground
> Between Irfon and Camddwr you are as far away
> As ever you will be from the world's madness.

The postcode seems to be SY25 6NP. It is around thirty minutes from the square in Tregaron (where it is signposted) on a good but single track road with passing places and one steep hill. If you approach from Abergwesyn, be prepared to negotiate a tortuous route up the Devil's Staircase, which features on lists of dangerous roads and as such draws a certain kind of enthusiast.

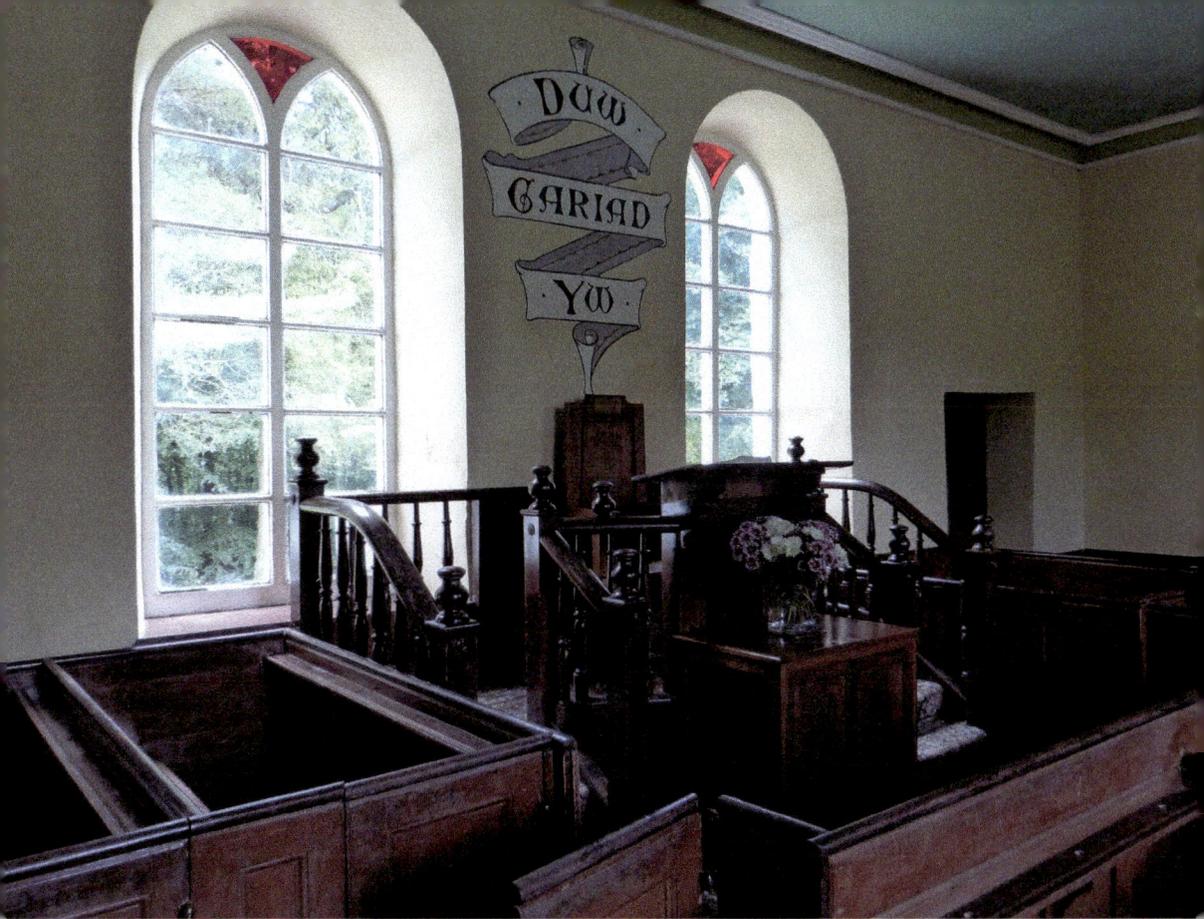

Duw Cariad Yw

Above: Inside the chapel. (Author's collection)

Right: The road from Tregaron. (Author's collection)

Anaddas i garafan
Unsuitable for caravans

Llyn Brianne 18

Soar-y-mynydd
Abergwesyn
ffordd gul
single track road

12. Tregaron

The Apostle of Peace

This is a comfortable place with a solid, reassuring permanence. Tregaron has expanded over the years of course, but the centre of the town is still the same. As it always was, so it still is the heart of a scattered community, with a weekly market and the annual Ffair Garon, held since 1292.

Tregaron was always on the drovers' route from West Wales to markets in southern England, with 30,000 cattle passing through every year before climbing into the wild hills above the town.

Today it brings walkers, not drovers. It is a 'Walkers are Welcome' town and there are plenty of routes for them around Tregaron. To the north of the town there is the Cors Caron – Tregaron Bog – one of the largest surviving bogs in the country and an important National Nature Reserve, a diverse and delicate environment with a number of marked walking routes. More sedentary visitors go to the excellent Rhiannon Centre in the square for the gallery, the craft shop and the very good café. I can recommend it.

On the other side of the road you will find The Talbot Hotel. Sadly the story that a Victorian circus elephant, Jwmbi, was buried in the back garden after

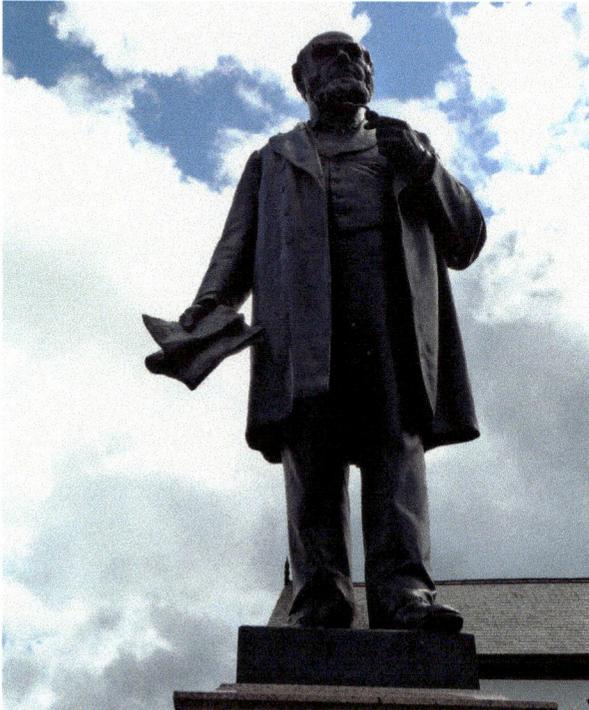

Henry Richard MP, the Apostle of Peace. (Author's collection)

dying on tour in 1848 is untrue – just as it is for all the pubs across the country that boast of similar elephant burials. Turn your attention instead to the front of the hotel and to the statue of Henry Richard, a true Welsh hero. He stands above us in his frock coat, in mid-speech. He has papers in his right hand labelled 'Peace' and he holds his glasses in his left.

He was known as the 'Apostle of Peace', the greatest pacifist of the nineteenth century. He was born in Tregaron in 1812 and his uncompromising Christian belief in non-violence underpinned everything he did. He was MP for Merthyr and Secretary of the London Peace Society, devoting his life to the cause of international peace. His is a surprisingly modern voice: 'Their subjects ask for bread, they give them bullets: they ask for useful education and they give them military drill; they ask for comfortable houses and they offer them barracks.'

In 1886 his motion that the country could only go to war with the consent of Parliament failed by six votes. Had he succeeded, the whole course of our history would have changed.

He died in 1888. His impressive tomb in Abney Park Cemetery in London is crumbling away but this statue in Tregaron is much more enduring.

The postcode for the centre of Tregaron is SY25 6JL.

Tregaron's Fallen.
(Author's collection)

13. Strata Florida

The Holy Grail

The Cistercian abbey of Strata Florida is set in the remote hills near Pontrhydfendigaid. It is neat, well-tended and atmospheric. The magnificent iconic arch that once framed the west door calls you in to the peace and the history within, although there is little left now of a building that was once larger than St David's Cathedral. The abbey was founded in 1164 and it became not only an important religious centre but also a place of political and cultural influence in medieval Wales. It was originally established a short distance away on the banks of the Afon Fflur and then moved to its present location. Important Welsh princes were buried here, like Gruffudd and Maelgwyn. There are eleven of them altogether, one of the reasons it was once regarded as the Westminster Abbey of Wales. It was badly damaged by a lightning strike in 1285 and a few years later it was burned on the orders of Edward I. It was finally destroyed in 1539 and the stones, as always, recycled locally. There are some who are convinced that the monks possessed The Holy Grail and took it with them to venerate it elsewhere and to mourn for the loss of their glorious solitude.

It was the Victorians who began the abbey's restoration when remoter parts of Wales were opened up by the railways. Steven Williams, the engineer building

Strata Florida. (Author's collection)

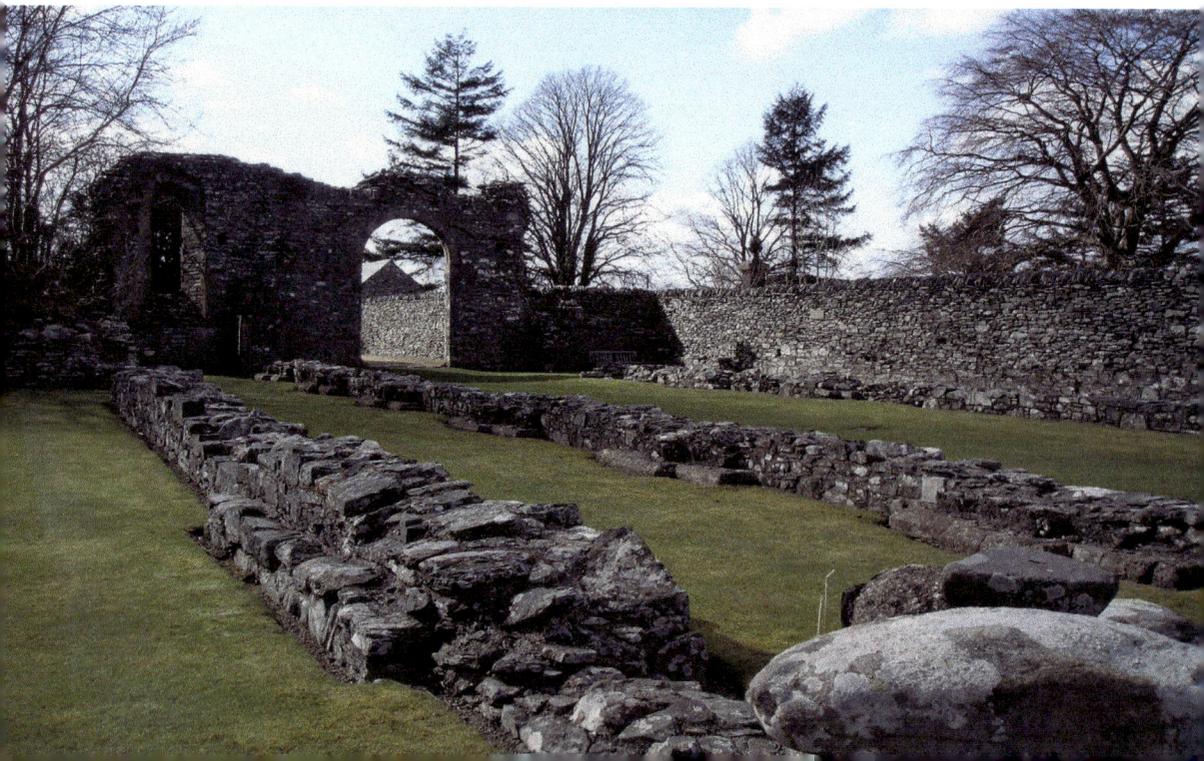

the railway line to Aberystwyth in the middle of the nineteenth century, began a huge excavation revealing most of what we see today.

An ancient yew is said to mark the grave of the great medieval Welsh poet Dafydd ap Gwilym, who may have lived and died here in the middle of the fourteenth century, possibly from the Black Death. Others suggest his real resting place is at Talley Abbey further south, near Llandeilo.

Close to the yew there is a considerable oddity: a gravestone which commemorates the left leg of Henry Hughes. If you look closely you can see its outline cut into the top of the headstone. The inscription reads 'The left leg and part of the thigh of Henry Hughes, cooper, cut off and interr'd here June 18th 1756.' The poor man lost his leg in a farming accident and emigrated to America. While the rest of Henry Hughes was eventually buried there, part of him was forever at home in Wales where he always had one foot in the grave.

Follow the signs to Strata Florida, east of Pontrhydfendigaid, from the B4343. The postcode is SY25 6ES.

14. Llangeitho

Jumpers

What makes Llangeitho a gem is that it has a special place in the history of Wales, as the destination for those who wanted to hear the famous and charismatic Welsh Methodist preacher Daniel Rowland. He was born in nearby Nantcwnlle in 1713 and was ordained at the age of twenty as a Church of England curate under his brother in Llangeitho. Daniel was a turbulent priest

and became one of the leaders of the Great Revival of the eighteenth century, using the dramatic rhythmic cadences of the Welsh language to become the voice of the Methodist revival.

Wales was 'in a most dangerous condition, going fast to eternal misery' and it seemed only the words of Daniel Rowland could save them. Thousands travelled from far and wide to hear his terrifying and uncompromising sermons advertising general damnation in Llangeitho's chapel. It had an external staircase to the pulpit, which allowed the preacher to appear suddenly and theatrically as if it truly was a visitation from God.

His technique was that he reminded his congregation of their essential wickedness and they in turn revelled in strident reminders of their own venality. His vivid descriptions of hell had the capacity to drive his congregation into a frenzy. 'What shall we do to save our souls?' they pleaded. Of course an attack on the dubious morals of your neighbours has a long and respected history in Wales. So how could his approach possibly go wrong?

Daniel never travelled far but then perhaps in Llangeitho he had a demanding workload. He believed his mission was to take the message to where the local people gathered, some of whom refused to go to church at all and instead amused themselves with 'sports and games' on a hill above Llangeitho. So Rowland went there 'suddenly breaking into a ring as a cock-fight was going on and preached of the sinfulness of their conduct'.

He was eventually deprived of his office by the bishop for preaching in unauthorised places and on the death of his brother the parish passed not to Daniel, but to Daniel's son John, which was a bit of a surprise. So Daniel acted as curate to his own son while continuing to preach in the meeting house constructed near the church.

Rowland died in 1790 and was buried in the village. In front of the chapel there is a memorial statue, judiciously surrounded by railings lest we should wish to clutch in fervour at his garments. Llangeitho is rather remote now but in the

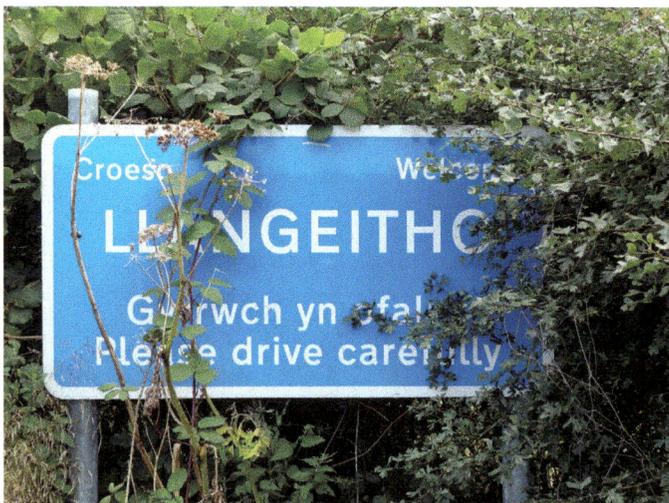

Welcome to Llangeitho. (Author's collection)

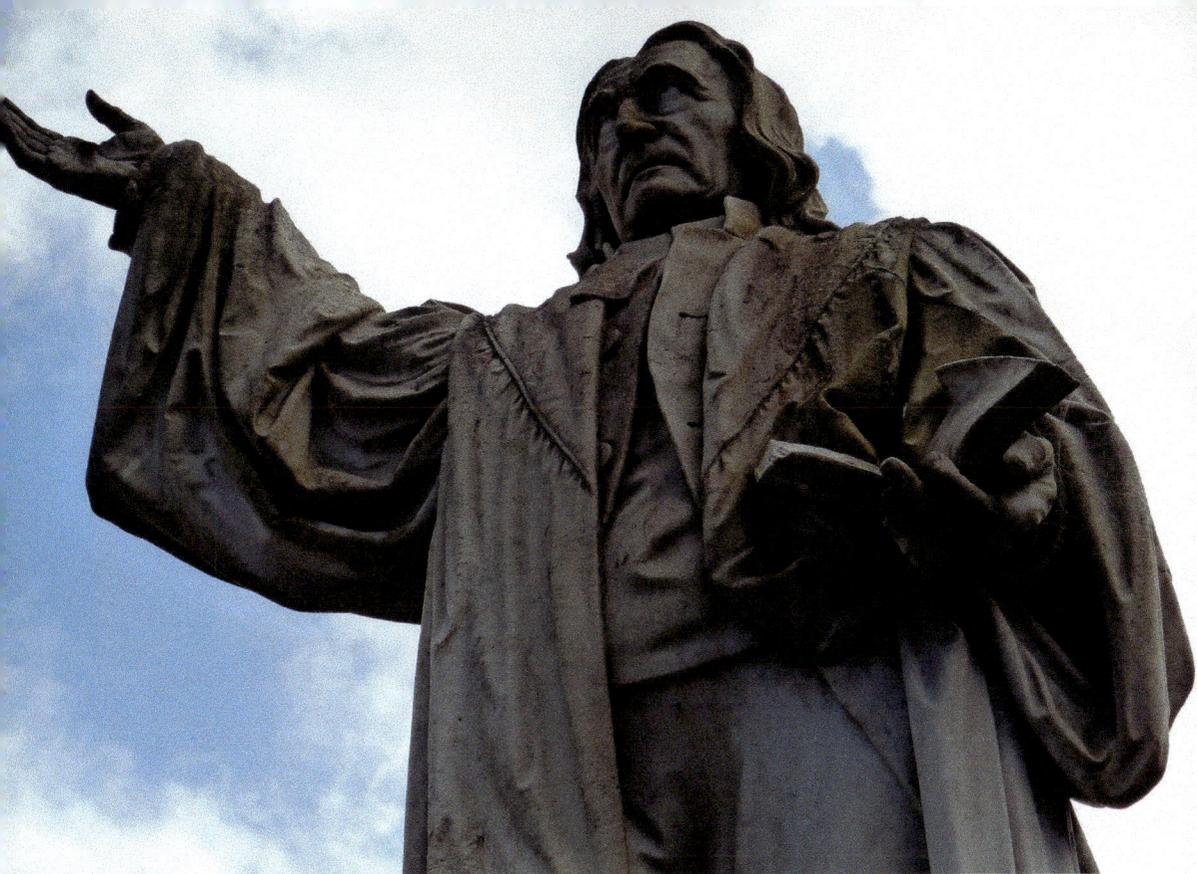

eighteenth century the village witnessed such religious mania, so much dancing and jumping, that Welsh Methodists were known as 'jumpers'.

Jumpers in Cardigan? Who would have thought it?

You can find Llangeitho on the B4342 west of Tregaron. Use postcode SY25 6TW.

15. Aberystwyth

Ceredigion Noir

There is a warmth about Aberystwyth, but not about the sometimes bitter wind or the tide that sweeps in from the bay, depositing large amounts of sand enthusiastically on the promenade. Malcolm Pryce in *Last Tango in Aberystwyth* says,

> Aberystwyth appeared in the valley below like a faithful dog, making the heart glad: skeins of smoke drifting across the slate roofs, the battered old pier and the pointy turrets of the old grey college, all set against the backdrop of a dove-grey sea.

It might sometimes feel isolated: the nearest places with any comparable population are Shrewsbury and Swansea, both over 70 miles away. But it is outward-looking and accommodating. It welcomes outsiders and is considered to be one of the best places to resettle. It is an important place too. It is a centre for local government, there are national government departments here, it is the home of the National Library of Wales, the site of an important hospital and of course the university continues to thrive.

Aberystwyth is still a popular seaside resort. It has a pier, a band stand, a shingle beach and a promenade beginning at Constitution Hill and stretching south to the harbour. You can see bow-windowed hotels and boarding houses stretching along Marine Terrace, although some are now morphing into apartments. Near the pier and the castle ruins you will see a wonderful Gothic building intended to be Aberystwyth's first luxury hotel. The original building was rebuilt in 1860 by a railway engineer who offered a free week's accommodation to anyone who bought a return rail ticket in London. Bankruptcy understandably followed and the building was bought in 1870 and became the first college of the University of Wales.

You can ascend Constitution Hill either on foot or by the Aberystwyth Cliff Railway to enjoy panoramic views and a camera obscura. The funicular railway opened in 1896 was initially operated by water-balance tanks on the front and then went electric in 1922, although the design of the carriages has remained unaltered. I particularly like the Ceredigion Museum next to the Tourist Information Office on Terrace Road. It has fascinating permanent displays and temporary exhibitions promoting the history and culture of the county. It is also

Towards Constitution Hill. (Author's collection)

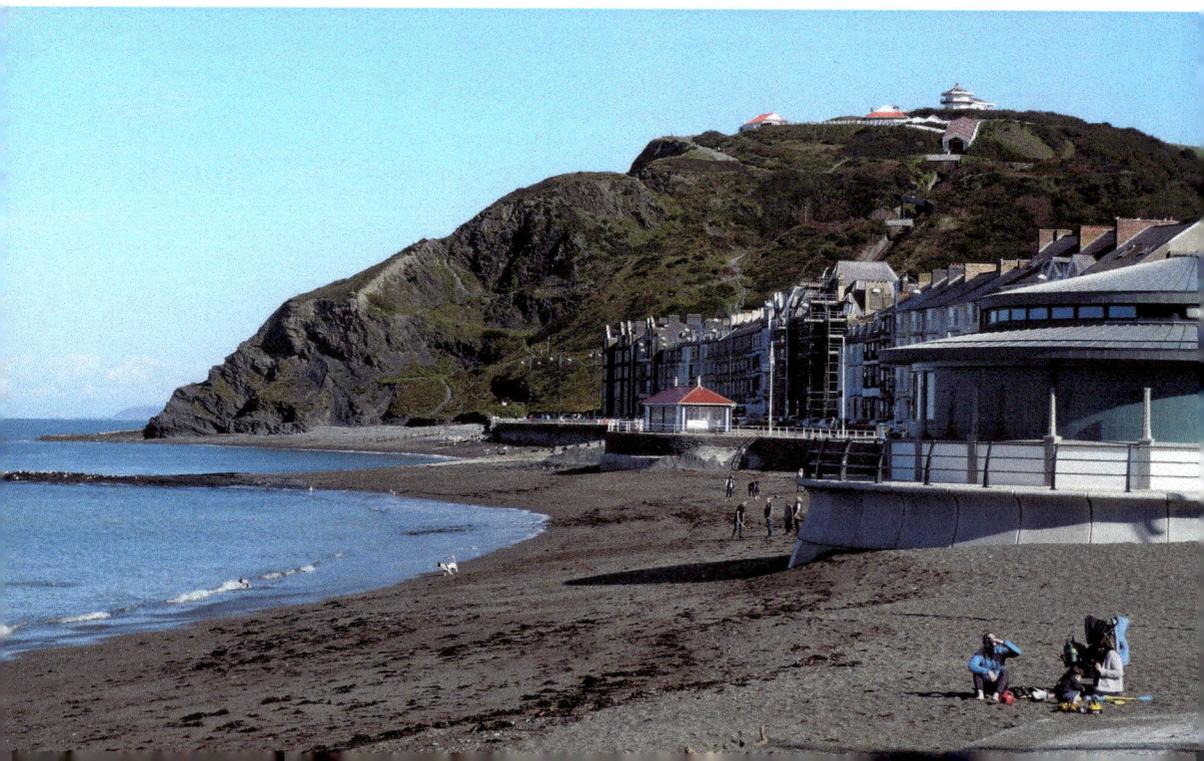

regarded as one of the most splendid of museum interiors, for it is housed in the Edwardian Coliseum Music Hall. Only in Aberystwyth …

The town is also the setting for a series of brilliant novels by Malcolm Pryce, which establishes a credible alternative universe where, along the mean streets of Aberystwyth, a private detective must forever walk. Aberystwyth: the home of Ceredigion Noir.

Aberystwyth sits at the end of the A44. Postcode SY23 2AQ will take you straight to the Ceredigion Museum.

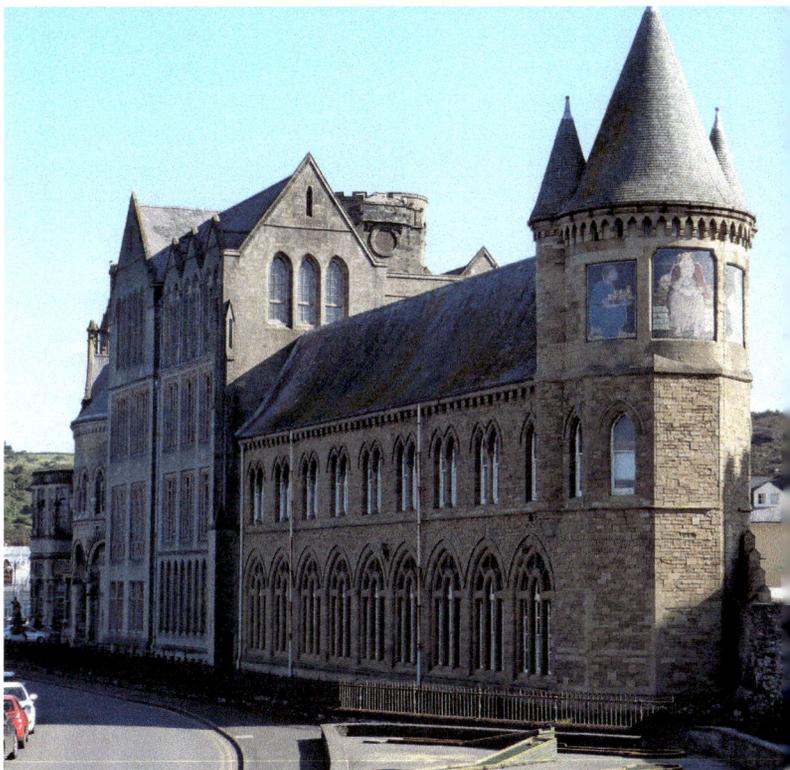

The first college of the University of Wales. (Author's collection)

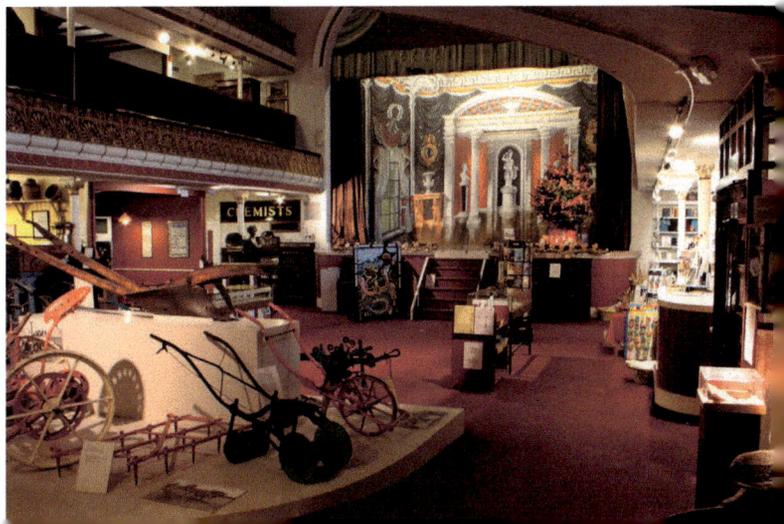

Inside the Ceredigion Museum. (With kind permission of the Ceredigion Museum, Aberystwyth)

16. The National Library of Wales, Aberystwyth

Permanently Precious

The National Library is a magnificent building, almost certainly the most important one we have in Wales. It is a 'storehouse of the most valuable books and manuscripts belonging to the Welsh nation', endlessly fascinating, permanently precious.

It is obviously the biggest library in Wales and as well as books it is the home of the National Screen and Sound Archive and has a fine collection of paintings. It is the repository for our knowledge and culture, with unique volumes that encapsulate our identity. It contains, for example, *The Black Book of Carmarthen*, the earliest surviving manuscript entirely in Welsh and the *Book of Taliesin*, a fourteenth-century volume of early Welsh poetry. It is also one of four legal deposit libraries, receiving a copy of every book published in England and Wales – even this one.

The library played a major role during the Second World War when some of the country's most precious artworks and manuscripts from the British Museum were stored in Aberystwyth away from the bombing raids. It had already been used briefly as a refuge for parts of the British Museum Collection in 1918 and the next evacuation of priority objects was planned as early as 1933. As soon as war was declared over 90 tons of treasures were taken to West Wales.

The library had constructed a special horseshoe-shaped tunnel as a carefully monitored safe house for the treasures. It had been proposed by Sir Evan Davies-Jones, the library's vice president, who had been involved in the construction of the Severn Tunnel and the Manchester Ship Canal, and conceived by Sir Charles Holden, who had designed a number of London Underground Stations.

The tunnel was 2 metres wide, 3 metres high, 25 metres long and had regulated temperature and humidity. For five years it provided comfortable hospitality for paintings by Rembrandt, Blake and Raphael, drawings by Leonardo and a copy of the Magna Carta. They didn't think that the Germans would bomb it since the prominent building was much more useful to them as a navigational aid for bombers.

Staff from London were impressed by the marvellous setting. Lionel Barnett, Keeper of Oriental Printed Books, said the Library 'was built with fine judgement on the summit of the hills … so we have on the one side the sea in all its glory and on the other the everlasting hills, green and purple'. I think they were rather sorry to go back.

The tunnel, its job done, now stands empty.

The postcode of the Library is SY23 3BU.

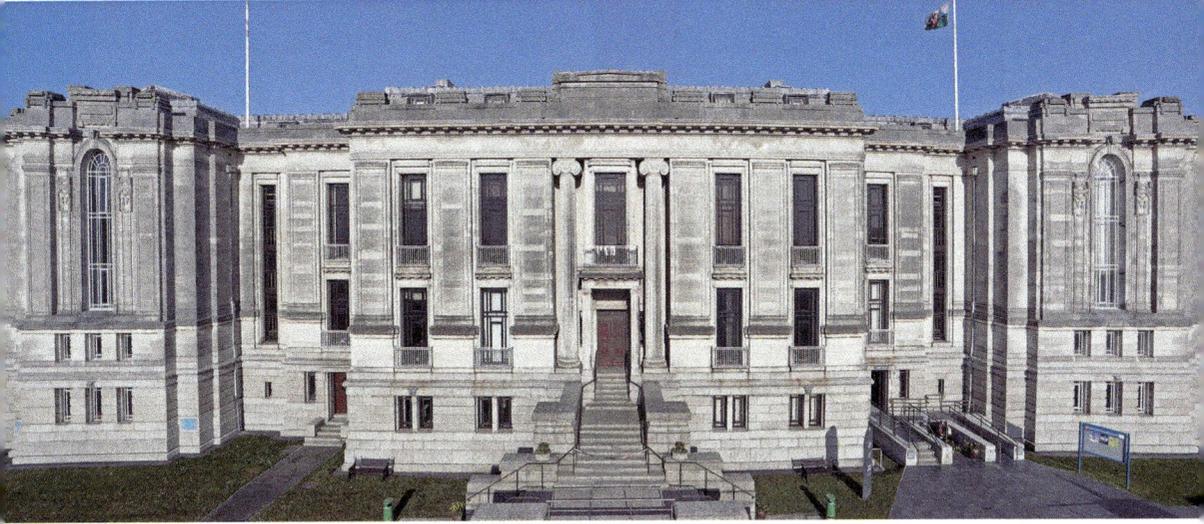

Above: The National Library of Wales. (With kind permission of Llyfrgell Genedlaethol Cymru/National Library of Wales)

Below: The Reading Room. (With kind permission of Llyfrgell Genedlaethol Cymru/National Library of Wales)

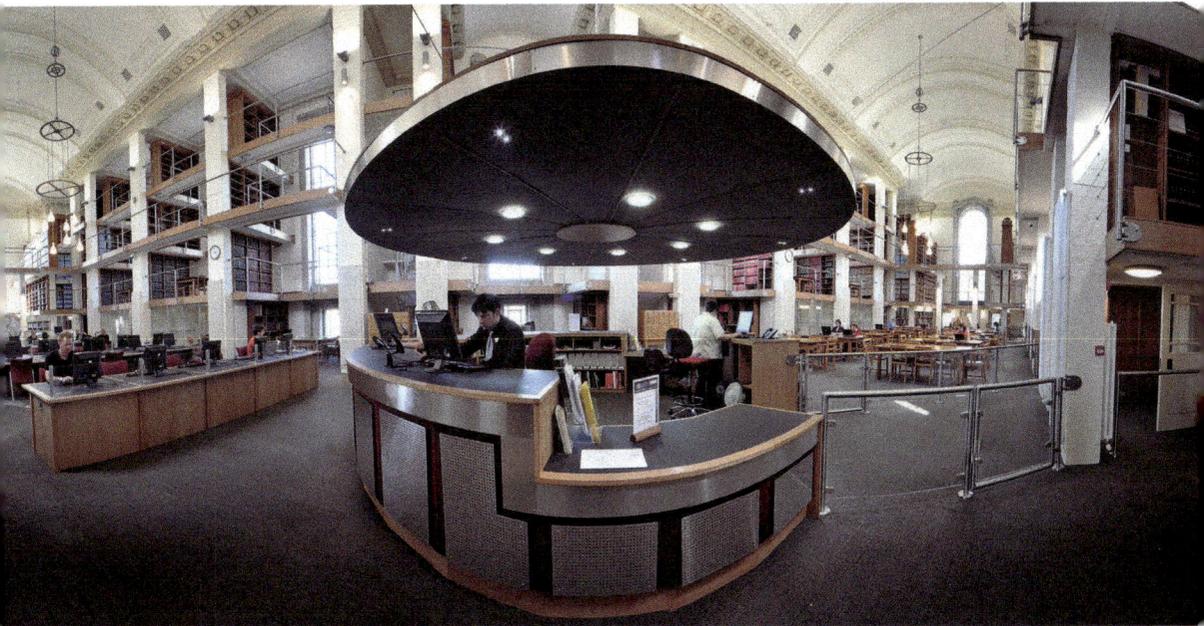

17. Borth

Welsh Atlantis

The holiday resort of Borth, 5 miles north of Aberystwyth on the B4353, has a long street of attractive houses protected from the attentions of the sea by a bank, although there are ominous road signs warning of flooding. Borth Community Council has, understandably, an Emergency Plan with forty-six flood wardens to monitor conditions.

The squadrons of caravans gather here for the shallow waters and the clean sand. It has always been popular, described in 1871 as 'a place of salubrity, quietness, a fine sea and beautiful country'.

The real gem of Borth, at the northern end of the beach, is a submerged forest. The stumps of ancient oak, birch and willow are generally hidden by sand and sea but are revealed at low tide. Radio carbon dating indicates that they died in around 1500 BC. They might be part of the 'Welsh Atlantis' – Cantre'r Gwaelog – a kingdom lost beneath Cardigan Bay. The legend talks of a fertile land sheltered from the sea by a dyke that was breached when the drunken Seithenyen neglected his duties at the sluices. Thankfully, the quality of flood wardens has improved considerably.

The postcode for the centrally positioned Borth Tourist office is SA23 2AG.

The Submerged Forest, Borth. (Photograph by kind permission of Hugh Lester)

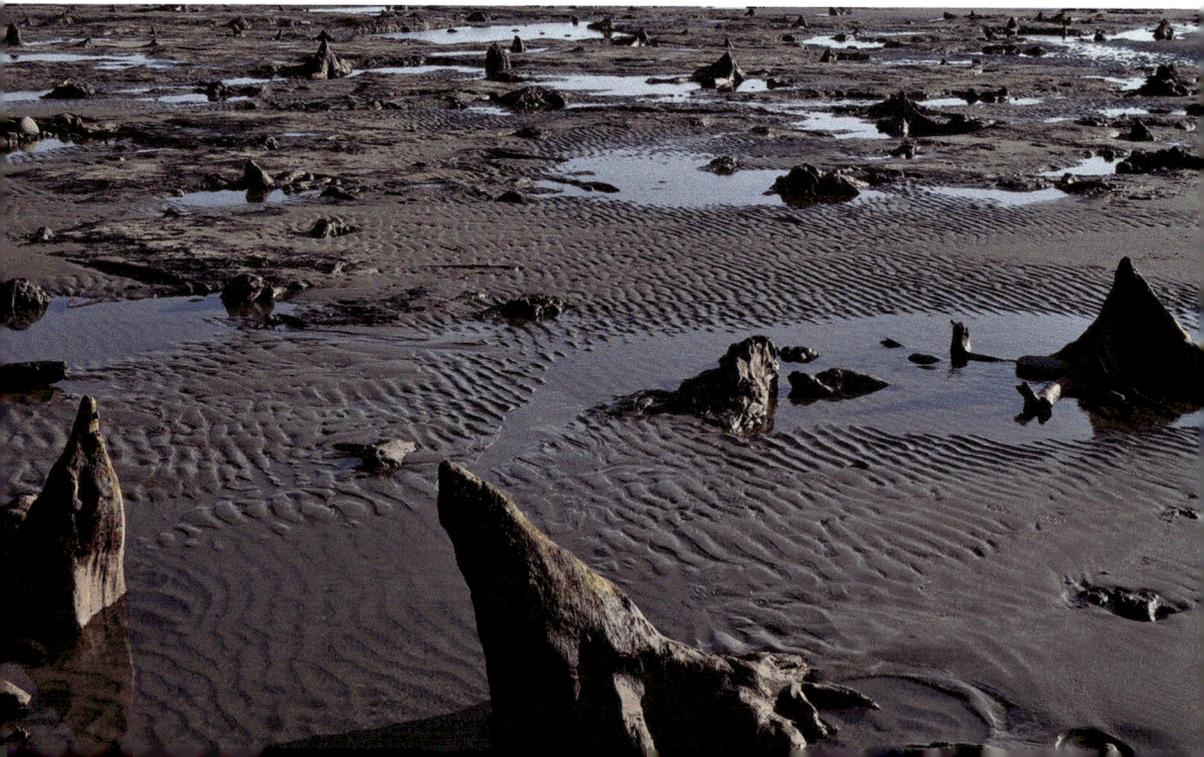

18. Bedd Taliesin

To Sleep on a Stone

To the east of the A487 between Aberystwyth and Machynlleth you will find Bedd Taliesin, an ancient burial site traditionally regarded as the grave of the poet Taliesin (534–99). However these are the remains of a Bronze Age cairn. The capstone has fallen and missing stones are now most probably contained within the local stone walls.

Taliesin was chief bard in the courts of at least three kings of Britain, and is associated with the *Book of Taliesin*, a text from the tenth century containing poems ascribed to him. He was venerated in medieval times as the founder of the Welsh poetic tradition, though much of the poetry ascribed to him was not actually written in his lifetime.

They say that anyone who sleeps on Bedd Taliesin will become either a poet or an idiot. My search for local poets has proved fruitless. Further research is required to confirm other aspects of the prophesy.

The cairn is best reached by car from Talybont (postcode SY24 5HE). Turn right by the church at the north of the village and take the minor road into the hills. After a mile you will find it on the right-hand side just above a farm.

Bedd Taliesin. (Photograph by kind permission of Scott Lewis)

19. The Vale of Rheidol Railway

A Beautiful Legacy

The Vale of Rheidol has a unique place in the history of the railways. For a long time until privatisation in 1989 it was the only narrow-gauge line operated by British Rail with their only remaining steam locomotives after they were abandoned elsewhere in 1968. It is now maintained by a charitable trust.

In retrospect the development of the line was one of those fortunate accidents of history when a particular set of circumstances has left a splendid legacy. The railway was developed for two reasons. One was to link the growing holiday resort of Aberystwyth and Devil's Bridge and the other was to support the lead mines operating in the Rheidol and Ystwyth valleys by building a branch line down to the harbour. There were some initial financial difficulties but the railway eventually opened for passengers in December 1902.

It was an initial success and particularly popular with summer passengers. Extracted ore was taken down to Aberystwyth, some of which began its journey when it was transported to the line by an aerial ropeway, along with timber, especially from the Hafod Estate (see entry), to be used as pit props in coal mines. The mineral traffic declined and the service to the harbour was abandoned. A new terminal for passengers was built beside the main-line station in Aberystwyth.

Of course as time went on it had to compete against the growing popularity of the motor car but despite occasional threats the Vale of Rheidol Railway has survived, for it accesses gorgeous scenery which the car user is denied and increases nostalgia for the age of steam. And, as steam trains do in their own peculiar way, it enhances an unspoilt valley.

The train begins at sea level and then makes its way up into the hills. The final stretch to Devil's Bridge goes along a ledge cut into the rock to give a constant gradient. It offers fantastic views. By the time it has reached the end of the line it is at a height of 680 feet.

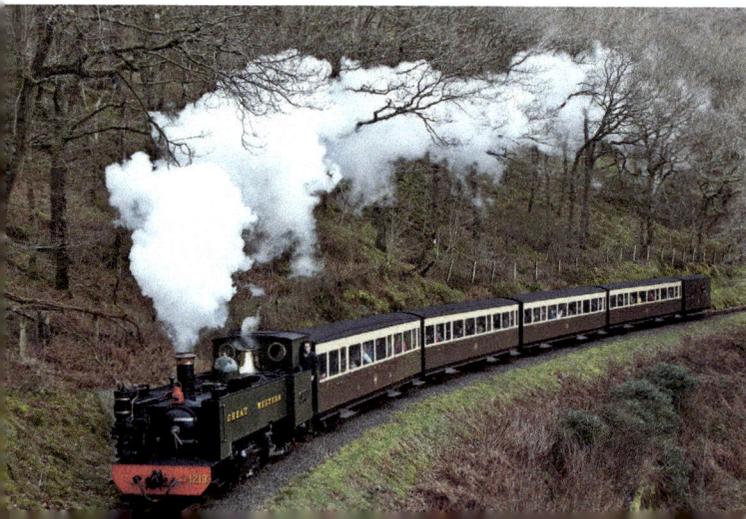

Photograph by kind permission of J. R. Jones and The Rheidol Railway.

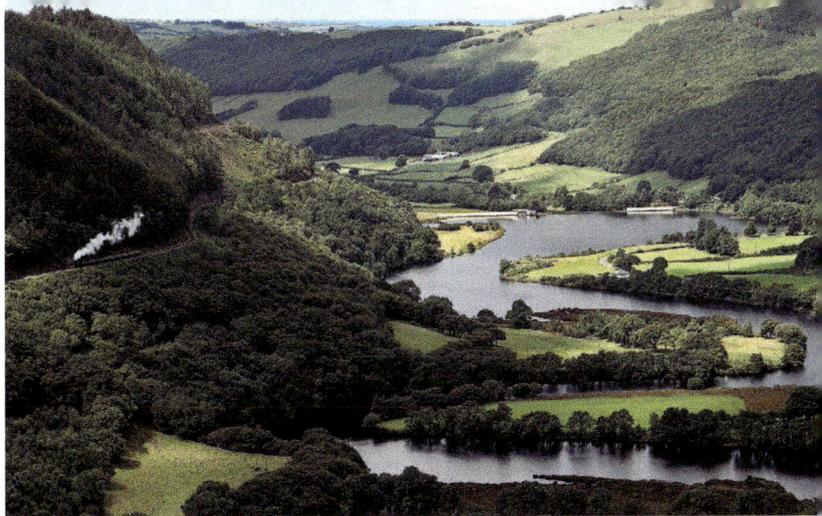

The Vale of Rheidol Railway has schemes and activities. Trains run daily from April to October with other occasional days in the winter months for such thrills as the Santa Special. It is an essential experience for enthusiasts and tourists alike but of course its greatest asset is that nostalgic journey through such idyllic scenery.

You can find the Railway terminal on Park Avenue close to the centre of Aberystwyth by following the brown train signs. The postcode is SY23 1PG.

20. Devil's Bridge

Rescuing a Cow

Devil's Bridge has been one of the most popular tourist destinations in Wales for centuries. In Welsh the name is 'Pontarfynach', meaning 'The Bridge on the Mynach', which is a more accurate description of what to expect. Except there is more than one bridge that crosses the Mynach, which is a tributary of the Rheidol. There are three of them, one on top of another. The most recent is the top one, built of iron in 1901. Beneath that there is a stone bridge erected in 1753 when the original twelfth-century construction was believed to be unstable. Who built this one is unclear. Claims have been put forward for the Knights Hospitallers, the monks in nearby Strata Florida and the Devil, obviously – but more of that below.

The Mynach drops 300 feet in five steps down a steep and narrow ravine before it empties into the Rheidol, carving dramatic, large potholes into the rock. The dramatic waterfalls are in a deep gorge below the Hafod Hotel and you must pay a small fee to see them. You can look from the road but they are best enjoyed in the depths of the wooded gorge where there is a viewing platform, reached by the ninety-one steps of Jacob's Ladder. It is worth the money: Turner painted it; George Borrow said it was 'one of the most remarkable locations in the world'; and Wordsworth wrote about it, describing 'woods climbing above woods, In pomp that fades not'.

Three bridges, with the Devil's at the bottom. (Author's collection)

From Devil's Bridge, looking down. (Author's collection)

There are two fine and accessible walks filled with ancient woodland and containing a hideout thrillingly called the Robber's Cave. There is also a wonderful view from the terrace in front of the Hafod Arms Hotel, which once provided accommodation for visitors to the Hafod Estate (see entry.)

And that name? The story is that the Devil agreed to build the bridge to allow an old woman, Megan, to rescue her cow, which was inexplicably trapped on the other side of the gorge. In return he would have the soul of the first creature that used the bridge, in the expectation that it would be her – well we have all come across builders with unreasonable demands. However, Megan threw a loaf of bread across it, which a local dog pursued eagerly, thus freeing the lady but condemning the dog to eternal damnation. Clearly you win some, you lose some; but the fact that the Devil was tricked by a Welsh Granny does rather call into question the sustainability of diabolic wickedness.

Devil's Bridge is on the A4120 around 10 miles east of Aberystwyth. Use postcode SY23 3JW.

21. The Hafod Estate

Shaping the Mountains

Hafod is quite extraordinary. Once the most visited place in Wales, it was the project of Thomas Johnes, who believed that he could tame and improve the wild uplands of the Ystwyth Valley. But his dream was haunted by fire and it destroyed him.

The Johnes family acquired the Hafod property to exploit its trees and its minerals but Thomas saw within it the possibility to create an elegant landscape to his own design. He told a friend that he had found 'paradise'.

He and his second wife moved to Hafod and their only child, Mariamne, was born in 1784. Soon a fine country house was constructed and visitors came to admire it and enjoy the extensive country walks with the 'majestic mountains and romantic rocky precipices' and 'rivers foaming in cataracts'. It was designed to be enjoyed on foot and sketching stations were provided where visitors could stop and draw the perfect views. They planted three million trees on the estate but the maintenance of such a huge project went far beyond his ability to sustain it. And Hafod was soon destroyed by fire and tragedy.

The house was burnt to the ground in a fire in 1807 and rebuilt, but the greatest tragedy of all was Mariamne. She was talented and gifted but chronically ill and died suddenly in 1811, aged twenty-seven. Johnes' purpose disappeared with her. In 1815 the family moved to Dawlish and Thomas died a year later in April 1816.

A statue of Mariamne by the great Victorian sculptor Francis Chantry was placed in Egwlys Newydd on the estate, but in April 1932 the church caught fire. The jets of water from the fire engines cracked the overheated marble of the statue and it shattered into fragments. In 1958 what remained of the mansion was demolished by explosives as a health and safety measure. The ruins are still there; you can scramble over them and mourn such a great loss.

The Lady's Walk.
(Author's collection)

The estate is now managed by the Forestry Commission and the Hafod Trust. The walks have been restored and clearly marked. They are different in their appeal and challenge but they are all special. Lady's Walk and Gentlemen's Walk will take you into the heart of the magnificent insanity of Johnes' design.

Behind the church there are the railings surrounding the Johnes family vault. Within it lie the remains of Thomas, Jane and Mariamne, and behind a screen in the church are the remains of Mariamne's statue, the final disaster of the Johnes family.

The Hafod Estate lies on the B4574 between Pontrhydygroes and Cwm Ystwyth. Postcode SY25 6DX.

On the estate. (Author's collection)

The Mansion. (Author's collection)

22. Bwlch Nant yr Arian

Fly a Kite

Bwlch Nant yr Arian is a good example of how a landscape can be restored and fulfil modern expectations. It was once the site of an old lead and silver mine, and now the excellent Forest Visitors' Centre attracts over 100,000 visitors a year. It is 9 miles east of Aberystwyth at the top of the valley near Ponterwyd and has a range of appealing outdoor activities. It offers an enjoyable day out accessible to everyone. You can get an idea of what is available from the National Resources Wales website, which has a host of downloadable guides to the various activities.

There are running trails, orienteering courses and three of the best mountain biking trails in Wales. An interesting circular trail for horse riders is well used and there are, naturally, clearly marked walking trails. One of them, The Miner's Trail, still carries a reminder of the lead mining industry here amongst the dramatic scenery on the boundary between the uplands of Mid Wales and the lowlands down to the sea.

One of the most spectacular attractions is the Red Kite Feeding station. The birds are fed every afternoon by the side of the lake and the spectacle is available to everyone since it is on the Barcud Trail around the lake, which is suitable for wheelchair users. Often over a hundred kites turn up for the buffet, circling like

Where kites are fed. (Author's collection)

vultures from an epic western set in Monument Valley. It is a spectacular event as they swoop in with a wingspan of 5 feet and their long forked tails.

These graceful and inspirational birds of prey have been saved from extinction by a well-managed protection programme – the longest continuous conservation project in the world. Nest protection schemes began in 1903 to counter 'the depredations of the carrion crow and the human egg collector' after it was reported in 1896 that only three of the six pairs in secret locations in Wales were rearing young. In earlier times they were welcomed to towns, where they helped to keep the streets clean, but their numbers declined once they were perceived as vermin and as a sporting opportunity.

Although they are still at risk from illegal poison baits left for foxes and rodents, the RSPB believe that there are now over 1,800 breeding pairs in the UK with around half of them in Wales. Bwlch Nant yr Arian is one of the best places to see them.

Bwlch Nant yr Arian is between Ponterwyd and Aberystwyth on the A44. Look for the brown signs. Access is free, although there is a small fee for on-site parking. The postcode is SY23 3AD.

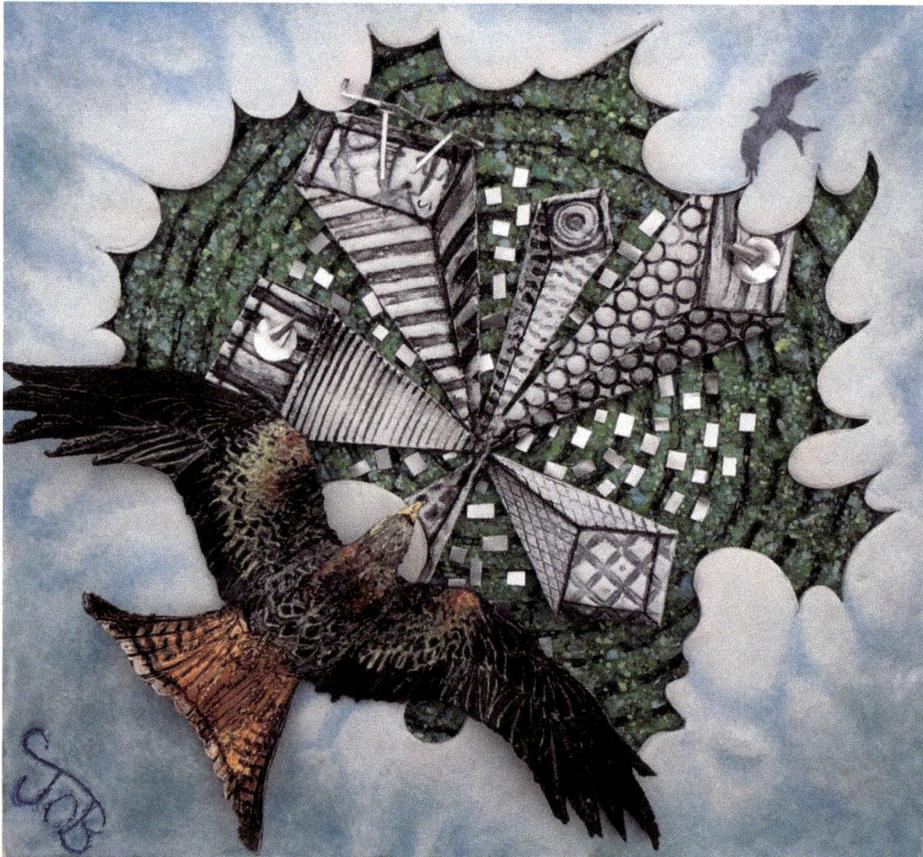

Milvus Milvus – original artwork by Jason O'Brien. (With the kind permission of the artist)

23. Cwmystwyth

Lead Astray

A fine, green frame surrounds a piece of the moon, fallen to earth. You can drive across from the upland beauty of the Elan Valley or you can travel from the sea along the Ystwyth valley to its upper reaches. Whichever way you come you will find a valley of exhausted lead and silver mines. They had been worked by people from the Bronze Age onwards, including the Romans and monks from Strata Florida. By the end of the eighteenth century this was the most advanced production site in the world. The valley as it appears today is awe-inspiring in its strange abandoned beauty, with ruins and thin vegetation the result of the toxic waste tips. There are lumps of quartz scattered around, a grey legacy.

People once lived here, as a nineteenth-century journalist said, amongst a 'vast field of mining machinery'. It was a dangerous place. Fatalities and serious injury were not unusual and due to acute lead poisoning the average life expectancy of miners was thirty-two.

Near Ponterwyd on the A44, the Llywernog Mine has been transformed into the tourist attraction The Silver Mountain Experience, with underground tours. Not only a rainy-day destination for holidaymakers but also one that provides an evocative reminder of a miner's life.

The postcode for Cwmystwyth is SY23 4AD.

Moonscape, Cwmystwyth. (Author's collection)

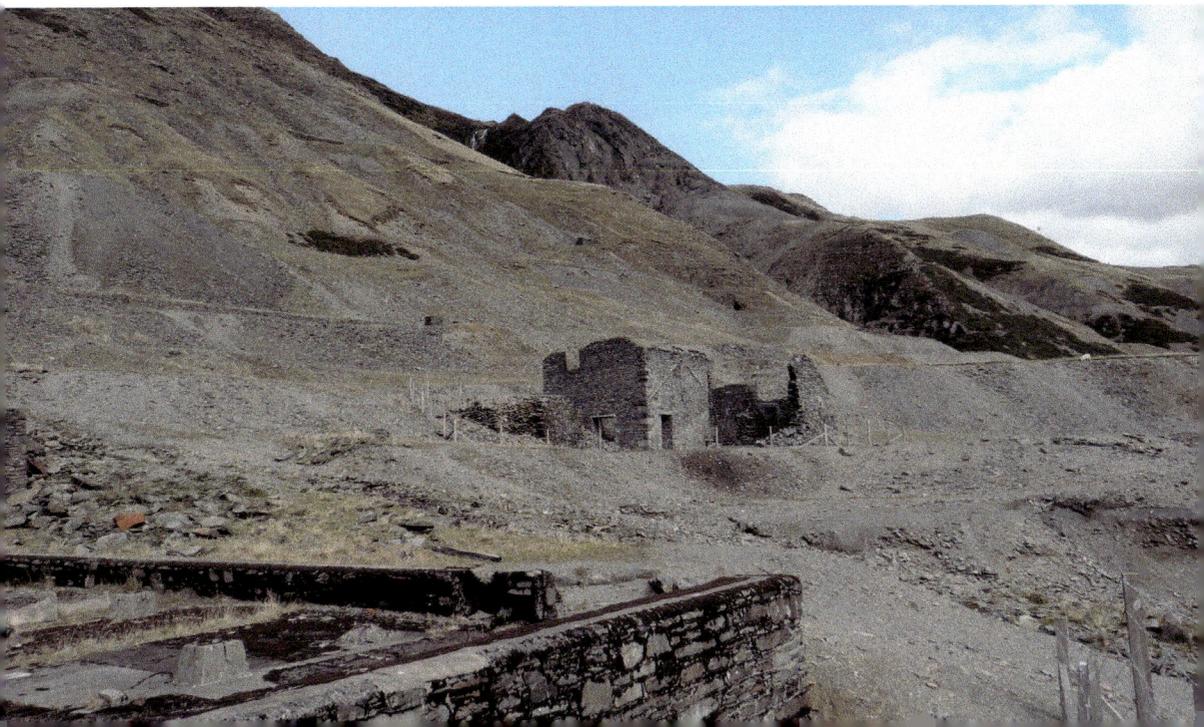

24. Elan Village

Dark Skies

Leave Rhayader and drive west along the B4518 towards Caban Coch reservoir. It is a lovely relaxing drive and soon you will see Elan Village signposted to your left.

Elan Valley is Wales' Lake District, a system of six reservoirs built to send water to Birmingham via a seventy-three-mile viaduct. To some, the lakes have enhanced the appeal of a wild and untamed area and have become a major Mid Wales tourist attraction, a celebration of engineering skill and municipal enterprise. To others this was an act of destruction and that anger still runs deep – a lasting symbol of English imperialism and exploitation, the sacrifice of Welsh valleys to slake English thirst.

The reservoirs were constructed between 1892 and 1904. Birmingham Corporation created a temporary 'navvies' village' to accommodate the workmen, who often brought their wives and children. This was Elan Village. As well as the huts in which workers lodged there was a hall, a school, a shop and a fire station, all beneath the dam wall but on the other side of the river from the road. This meant that access to the village could be controlled across a bridge. Large numbers of workers came to Elan but new arrivals had to be examined and cleaned in the Doss House before they could cross the bridge in order to control infections.

There was also a hospital as accidents were frequent, especially eye injuries from working with stone. Fatalities were not uncommon. In 1898 eleven-year-old Walter Bennet was decapitated while cleaning a crane. There was also a licensed canteen supplying alcohol, although consumption was closely regulated and no women were allowed in the bar. It yielded a 93 percent profit, which was used to maintain the school and other facilities in the village like the free library. At its height it housed 1,800 adults and 200 children.

All human life was here. In December 1898 the press was excited to report that Alfred Ford, a labourer, ran off with his landlady, Mrs Cumberlidge, the sixth such elopement since the work began.

When the project was finally completed the wooden village was demolished, although the visitors' centre is housed in some of the original workshops. The village you see today was built in 1909 to house those who maintained the reservoirs. There are eleven detached and semi-detached properties and a school, all finished with local rock-faced masonry in an Arts and Craft style, looking like an elaborate filmset for a mysterious sixties thriller. It makes Elan Village an idyllic gem.

The visitors' centre at Caban Coch (postcode LD6 5HP) tells the story of how these valleys were transformed.

Elan Village. (Author's collection)

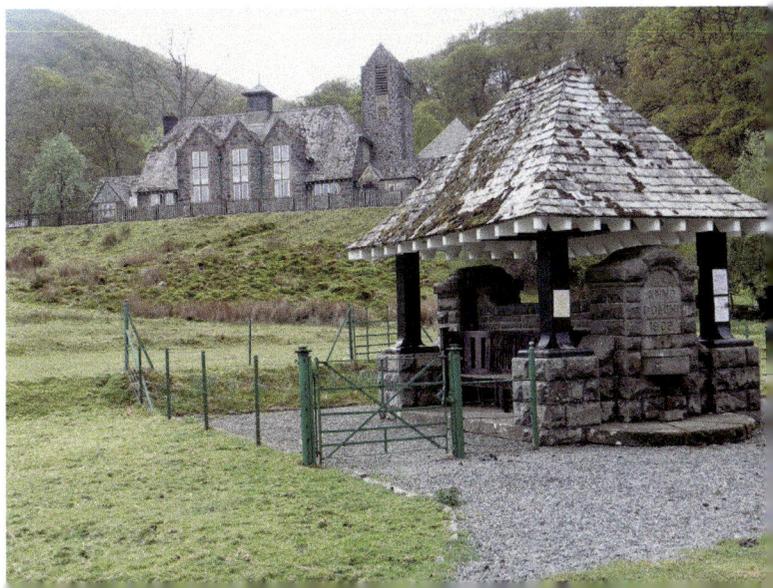

Towards the school. (Author's collection)

25. Llanidloes

Crossroads

Llanidloes is a very attractive place, the first town on the Severn as it flows down to the Bristol Channel, lying at the confluence with the River Clywedog. The wealth of the town came originally from lead mining and the woollen industry, but it has adapted to the modern world and serves the needs of refugees from the city, who enjoy its relaxed pleasures and easy access to splendid countryside.

In the heart of the town where four roads meet there is the iconic black-and-white market hall. It was built on stilts in 1600, beneath which the market once took place. In its time it has been used as a courthouse and a Quaker meeting room, a library and a workingman's institute. They also locked up drunks under the stairs. There is a stone at one end of the building from which John Wesley once preached. Today the traffic eases itself in a respectful fashion around a building that represents the town in the eyes of the rest of Wales.

Leading away from the market hall, Great Oak Street is broad and expansive. It is where you can find the town hall and the tourist office, a building which was once a temperance hotel. On the opposite side of the road there was The Trewythen Arms, which was stormed by Chartist activists in 1839 to liberate arrested colleagues and to attack the constables sent here to monitor political unrest amongst flannel weavers. It is hard to imagine that Llanidloes was ever the kind of place where such things could happen.

In the parish church of St Idloes you can enjoy the elegant arches and the hammer-beam roof (with angels at the end of the beams), which came from Abbey Cwm Hir. These substantial arches dwarf the rest of the building.

The Roman Catholic Church in the town is dedicated to Richard Gwyn, Llanidloes' only martyr, who was burnt in Wrexham in 1584 for refusing to accept the Reformation.

The town is a good touring base. Clywedog Reservoir is not far from town, with Britain's tallest concrete dam overlooking the remains of the Bryntail lead mine. There is also the vast Hafren Forest, which stretches up the eastern slopes of Plynlimon. If you are so inclined you can walk up to the source of the River Severn. Glyndwr's Way, which meanders through 135 miles of Mid Wales from Knighton to Welshpool, runs through Llanidloes and brings plenty of business to the town from those eager for well-deserved refreshment.

Llanidloes is on the A470. Postcode SY18 6BW will take you straight to Great Oak Street.

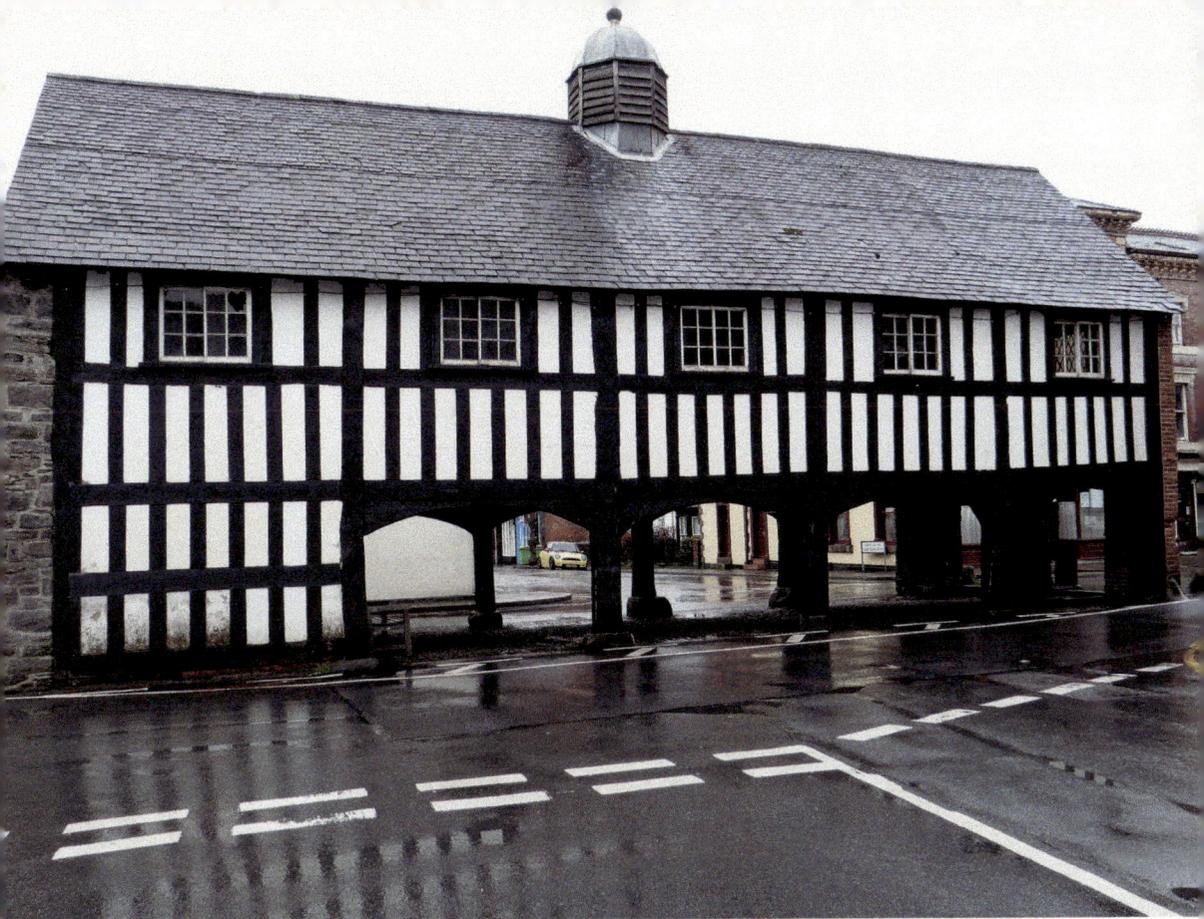

Above: The Market Hall. (Author's collection)

Right: The Arches from Abbey Cwm Hir. (Author's collection)

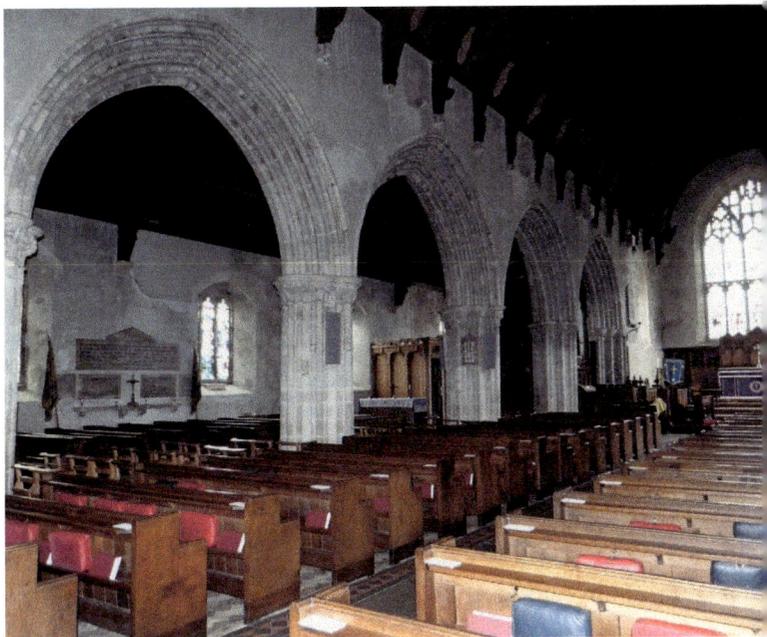

26. Machynlleth

Parliament House

There is a lot of history in Machynlleth. The Romans were here, drawn by its strategic position at a bridging point across the Dyfi, now the north-western border of Powys. They called it Maglona and there are the remains of a small Roman fort nearby at Pennal, but there are more significant buildings in the town itself, especially the Parliament House in Maengwyn Street.

This is now the Owain Glyndŵr Centre, which celebrates the life of the rebel leader and national hero. Here Owain Glyndwr was formally crowned Prince of Wales in 1404 in the presence of representatives from France, Spain and Scotland. He established a parliament here briefly before his rebellion collapsed and he became a fugitive, probably living out his last years in Herefordshire after laying waste to a number of the places in this book – though I am not inclined to take it personally.

It was in Machynlleth that Glyndwr narrowly missed assassination at the hands of his brother-in-law, Dafydd Gam, described by John Tillotson in 1860 as 'a treacherous man, a dove-feathered raven with a dagger under his vest'. Gam was consequently imprisoned on the site of the Royal House, a distinguished half-timbered merchant's house, also on Maengwyn Street. He was released and was killed in the Battle of Agincourt in 1415. It is called the Royal House because it is believed that Charles I once stayed here. There was in fact a battle down by the Dyfi Bridge in 1644 during the Civil War.

The iconic image of Machynlleth is the clock tower, which stands in the middle of town on the site of the old town hall, which had been erected in 1783. The tower was built by enthusiastic public subscription in 1874 to mark the coming of age of Lord Castlereagh, who lived in Plas Machynlleth, the local mansion house. The *Aberystwyth Observer* noted that watched by cheering children freed from school, 'a bottle containing several coins of the realm and daily and local newspapers, was placed in a cavity under the foundation stone, and a trowel being handed to the noble Viscount, he very skilfully spread the mortar on the bed of the stone, and declared the same to be perfectly laid'. A multifaceted young man indeed.

Parliament House. (Author's collection)

Today Machynlleth has pleasant shops offering local crafts and organic foods and there is a Wednesday market for which the town received a Royal Charter in 1291. The town is also the home of the Museum of Modern Art (MoMA), Wales, and I am especially reassured by publicity material for the annual Machynlleth Comedy Festival, which now proudly confirms the availability its own campsite with flushing toilets.

Machynlleth is at the junction of the A487 and the A489, postcode SY20 8EE.

Above: Black and white houses dated 1628, Machynlleth. (Author's collection)

Right: Clock Tower. (Author's collection)

27. Centre for Alternative Technology

Environmental Inspiration

In November 1901 the Revd Dr Griffiths visited Pantperthog Chapel, near Machynlleth, and gave what must have been a very interesting talk about his missionary work in the Khassia Hills in India.

Today there are other missionaries in Pantperthog, for just over the border in Powys is the home of the Centre for Alternative Technology. It is a fascinating place that will challenge your preconceptions and give you a range of ideas that you will be eager to try out at home.

The centre started in 1973 and has become a major centre for 'environmental inspiration', promoting a sustainable future by offering innovative alternatives to our wasteful practices. The CAT is based in the abandoned Llwyngwern Slate Quarry, which was initially entirely inhospitable but which has been transformed through organic growing methods. During the last forty years a garden has emerged from the unpromising slate debris. Composting and managing wastes have been crucial in the creation of soil fertility. The compost toilet should definitely be on your itinerary for it is where all visitors can make a genuine contribution to the project.

There is a zero carbon trail and you can see the impact that properly run wind turbines and solar panels can make. Hydropower plays its part too, as you see immediately on arrival with the iconic water-balanced cliff railway pulling summer visitors up a 35-degree incline to the entrance of the quarry. The low-energy house is a popular feature, the most insulated house in Britain. Its mission is to show how we can all make changes in our own lives. The centre has a fine café that sells their own produce and it promotes alternative protein sources like beans and peas.

Children can enjoy themselves here. There are play areas and appropriate displays with plenty of hands-on opportunities. It is the perfect place for some of those wet holiday hours in Mid Wales. Visitors will inevitably reflect on their own lives as we try to manage dwindling resources in an over-populated world.

The pioneering CAT has had an impact on the whole of the local area, not only by creating jobs and attracting over 70,000 visitors a year but also by increasing environmental awareness in the Dyfi Valley, which is now a UNESCO Biosphere Reserve.

The CAT is right on the border with Gwynedd but thankfully manages to squash itself into the book. It is north of Machynlleth and is signposted from the A487 towards Dolgellau. The postcode is SY20 9AZ.

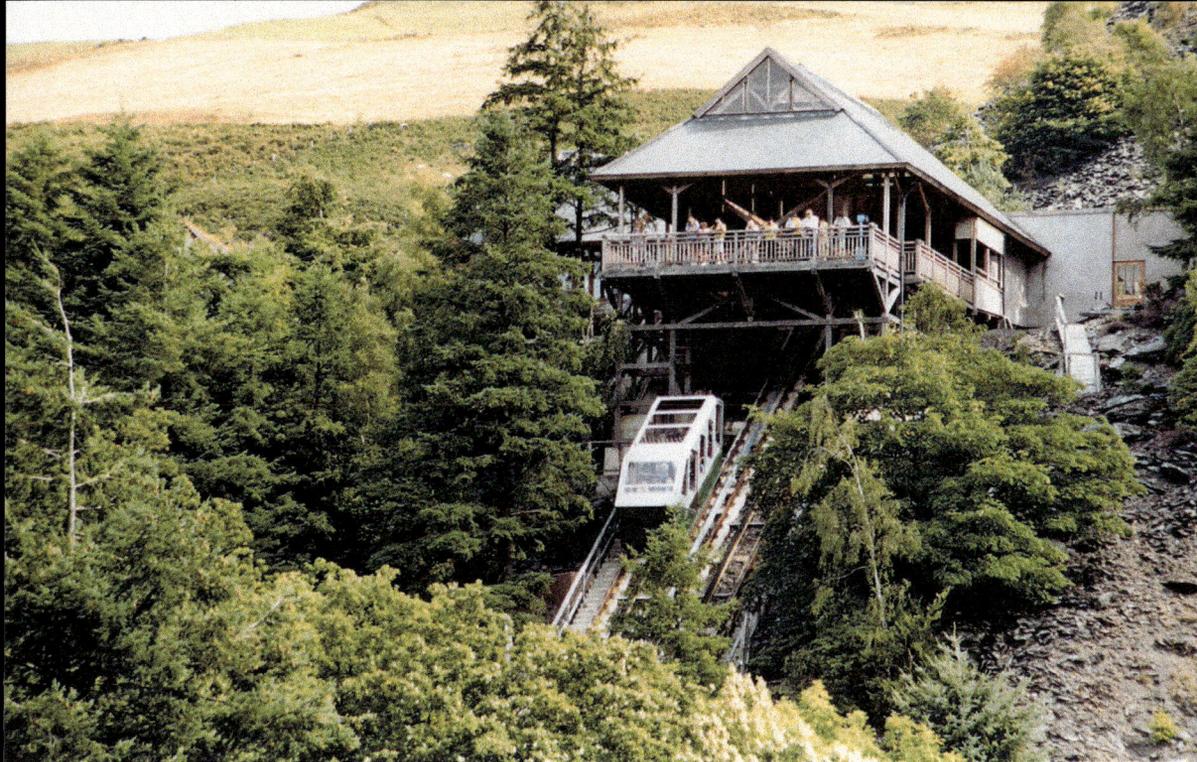

Above: The Cliff Railway. (Photograph by kind permission of the Centre for Alternative Technology)

Below: The Wales Institute for Sustainable Education. (Photograph by kind permission of Timothy Soar)

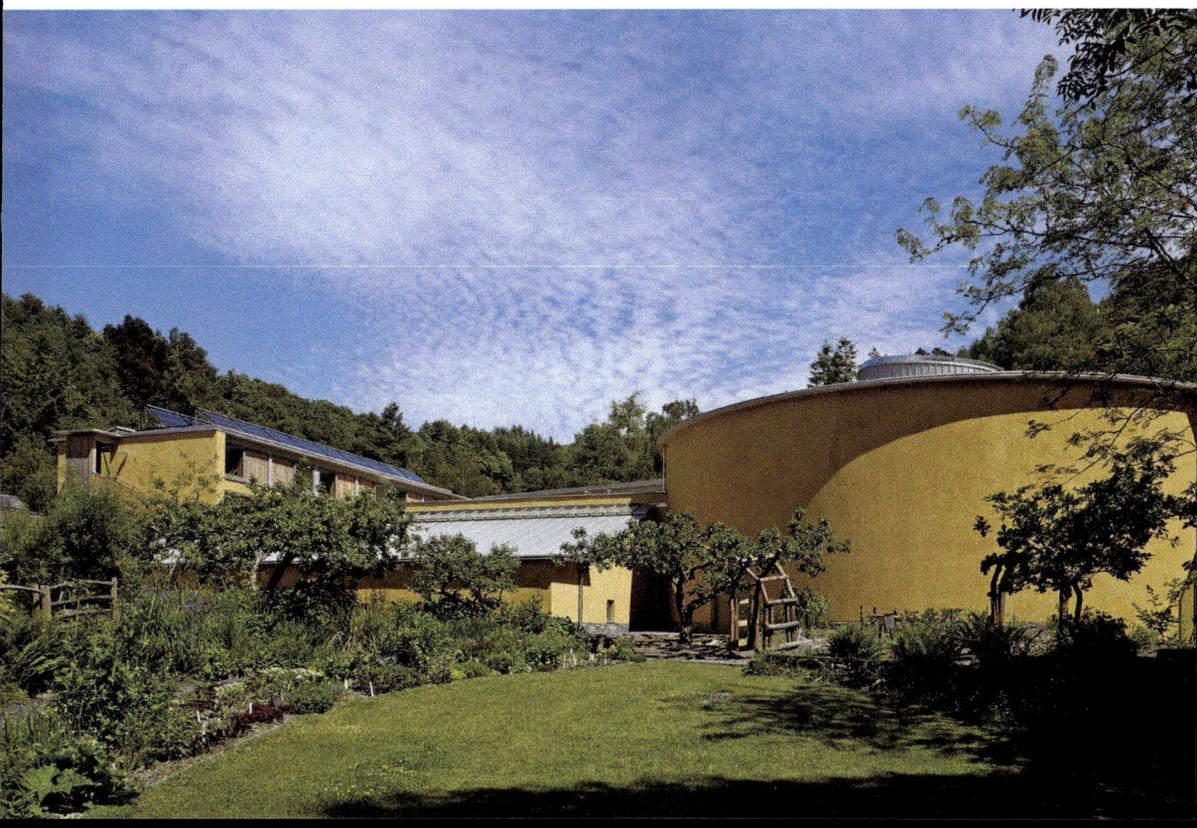

28. Newtown

Influential Residents

Newtown is the birthplace of two men who had an outstanding impact on our lives in completely different ways and who are remembered in this attractive town alongside the Severn.

Let us begin by the side of the busy A483 where you can see two tall, distinguished red-brick temples to commerce, the Royal Welsh Warehouse. These buildings tell the story of Pryce Pryce-Jones (1834–1920), an entrepreneur who transformed his town, transformed his own life and built the future.

He began work as a draper and soon saw an opportunity to develop a mail-order business which initially merely involved sending out patterns and stocklists. He knew there was an untapped market in isolated rural locations like Mid Wales where shops were few. Why not take the shop to them? Pryce produced an illustrated catalogue and used celebrity names like Florence Nightingale in his advertising. He linked distribution to production by arranging for local woollen manufacturers to supply goods in response to orders and set up distribution networks, developing the parcel post.

The Royal Welsh Warehouse still has attractive panels showing ships and trains and cities that are certainly worthy of your attention. As you look at them, remember that Newtown was where shopping changed forever.

Robert Owen (1771–1858) was a visionary too. He was born and was buried in Newtown and his alternative social vision has touched the lives of millions. There are those who think that he was the greatest Welshman of them all. I think they are probably right.

He had a paternalistic desire to improve the lives of others through a combination of co-operation and self-help. He was certainly one of the most significant figures of the nineteenth century, combining capitalism with a concern for the well-being of his workers in his mills, which is reflected in his influence on the co-operative movement.

His grave, which he shares with his parents, has been twice restored. It was surrounded by fine ornate railings erected by the co-operative movement in 1902, which give it the prominence the grave deserves, and it was all spruced up again in 1993. You can find his imposing tomb in the churchyard of St Mary's in the middle of town and there is a fine statue too on Shortbridge Street.

On the ground floor of the council offices in the middle of town there is the instructive Robert Owen Museum, essential for all visitors to Newtown. The plaster cast of his, face made when Owen was fifty, brings you closer to such an influential man.

The postcode of the museum is SY16 2BB.

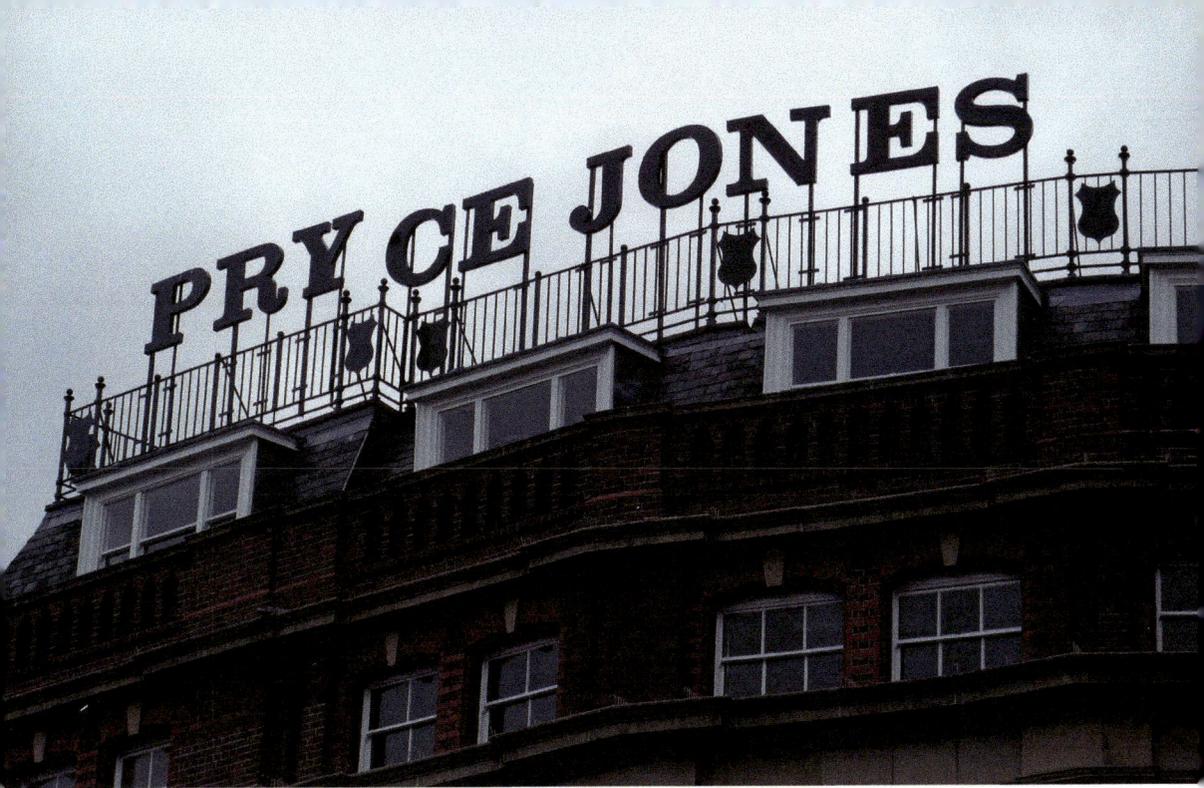

Above: The Royal Welsh Warehouse. (Author's collection)

Right: Robert Owen on Shortbridge Street. (Author's collection)

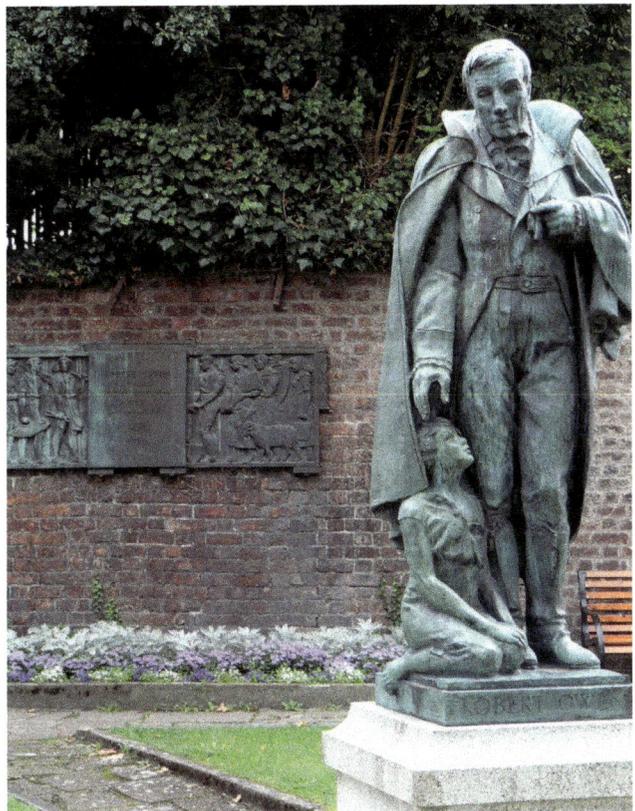

29 Gregynog Hall

Two Sisters

In March 1914, after Gregynog Hall had already been purchased by MP ('and young millionaire') David Davies, admiration for the building was such that the *Cambrian News* suggested it should become the official residence of the Prince of Wales. It didn't happen of course, but the ownership of this distinctive building by the Davies family from Llandinam created a different but enduring legacy.

Perhaps Gregynog's story is best represented by the work of 1840, which wrapped the building in the warm protective embrace of a striking concrete façade. It is subsequent events that happened inside the concrete that have secured its place in this book, but beneath this homage to the black-and-white farmhouses of Montgomery, there is another hidden history of over 800 years.

It was David Davies' sisters, Gwendoline (1882–1951) and Margaret (1884–1963), who assumed ownership in 1920 and changed Gregynog, committing the house to artistic appreciation and achievement. They started the Gregynog Press in 1922 to produce prestigious hand-printed books using traditional printing techniques and established the Gregynog Music Festival in 1933, now Wales's most prestigious classical musical festival. It was, however, their art collection that bequeathed to the property its lasting fame.

During the First World War they had worked in a canteen for French soldiers in Troyes. Their grim experiences convinced them that they should use their considerable wealth to enrich the world into which Welsh soldiers would return by using the healing power of beautiful things. They bought paintings with an uncanny grasp of what future generations would value. They acquired work by artists such as Monet, Renoir, Cezanne and Pissarro and created an astonishing collection of French art. Their collection of 260 paintings was eventually donated to the National Museum of Wales, transforming the nation's art collection. It is worth going to Cardiff just to see this wonderful collection, particularly the tranquil beauty of *Woman and Child in a Meadow at Bougival* by Berthe Morisot.

These singular sisters also gifted Gregynog Hall to the University of Wales and it is now used as a residential conference centre and a romantic wedding venue.

Today you can enjoy the magnificent landscape, which has vistas and formal gardens dating back to the sixteenth century. There are graded walks, excellent tea rooms and a pleasant shop. The hall also offers elegant accommodation for visitors, certainly the best way to fully appreciate this splendid place. It represents another age with priorities so different from our own. That combination of wealth, privilege and responsibility has left an heirloom for us all. Gregynog is one of the true gems of Mid Wales.

Gregynog Hall is 4 miles north of Newtown in the village of Tregynon. Use postcode SY16 3PW.

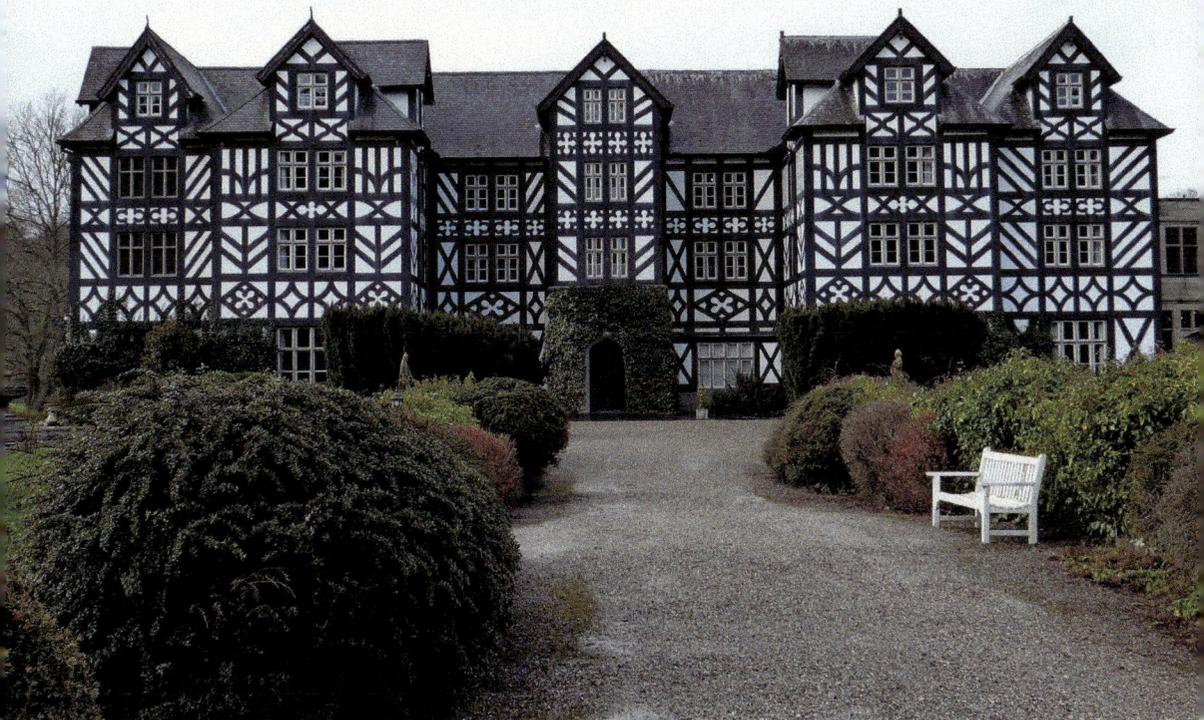

Above: The concrete façade of Gregynog Hall. (Author's collection)

Right: The library corridor. (Photograph by kind permission of Gregynog Hall)

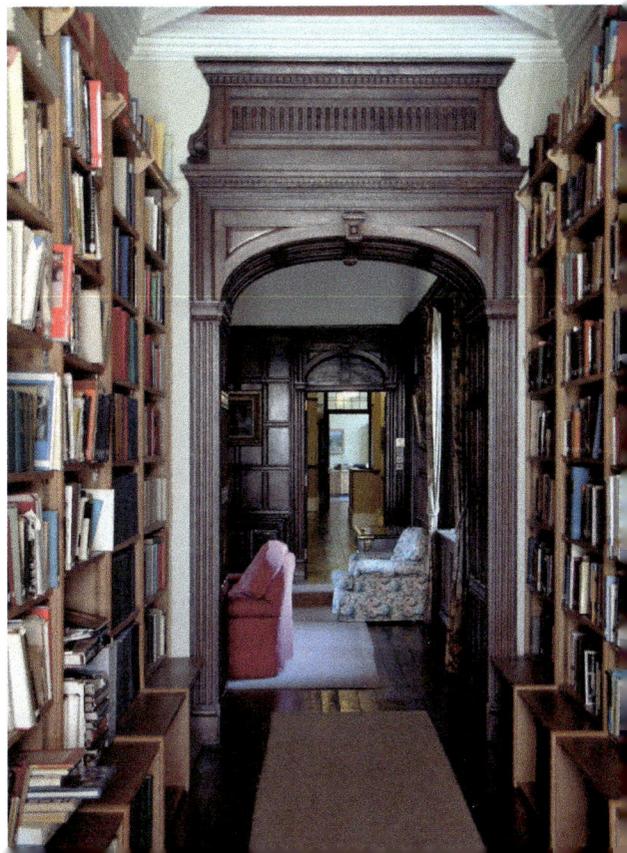

30. Lake Vyrnwy

Purity

Beneath Lake Vyrnwy is the original site of the village of Llanwddyn. It was described in 1852 as an 'obscure but romantic and picturesque village' with three inns, a post office, two chapels and thirty-seven farmhouses. And then Liverpool came to call.

The city needed clean water to support its hectic urban growth and Llanwddyn was perfect. A reservoir here could collect water 'sufficiently free from lime and other mineral matter to be soft enough for steam, washing and manufacturing uses' with 'just enough of these ingredients to render it palatable for drinking purposes'.

The original residents naturally objected to the description of their village by a Liverpool councillor as 'the most God-forsaken place in the world', since even the most cursory of visits to Liverpool would make such an opinion unsustainable. But they were well looked after by Liverpool Corporation and were quite pragmatic about it all: the incentives they received outweighed the pain of relocation, for they were moving into good, solid stone houses, still standing proudly today.

Their village became a huge construction site with over a thousand labourers, a steam-driven tramway and cranes. They lived amongst it all as the great dam wall was constructed. No dam had been built out of stone before – they used over half a million slate blocks. They began in 1881 and by 1889 the old village was destroyed with dynamite and a hundred skulls, and other remains from the cemetery were removed to the new burial ground. Before the end of the year the reservoir was full and water was, as planned, flowing over the top of the dam.

The lake's most famous landmark is the Gothic-style Straining Tower, which stands close to the shore like a castle on the shores of a Swiss lake. It is a fantastic – and functional – folly. It removes debris before the daily dose of 54 million gallons sets out on its gravity-powered 75-mile journey to Liverpool.

The lake is a haven for wildlife. On completion birds and game were released and the water was stocked with 400,000 trout from Loch Leven. Many people describe the lake as their favourite place in Wales, an undisputed gem. They come to drive, to walk, to ride and to enjoy the striking sculpture park.

The purity that brought Liverpool here in the first place still remains. Whatever you think about the export of Welsh water, you will acknowledge that at Lake Vyrnwy it created something beautiful.

Lake Vyrnwy is north-west of Welshpool on the B4393, close to the border with Gwynedd. The postcode of the visitor centre is SY10 0LZ.

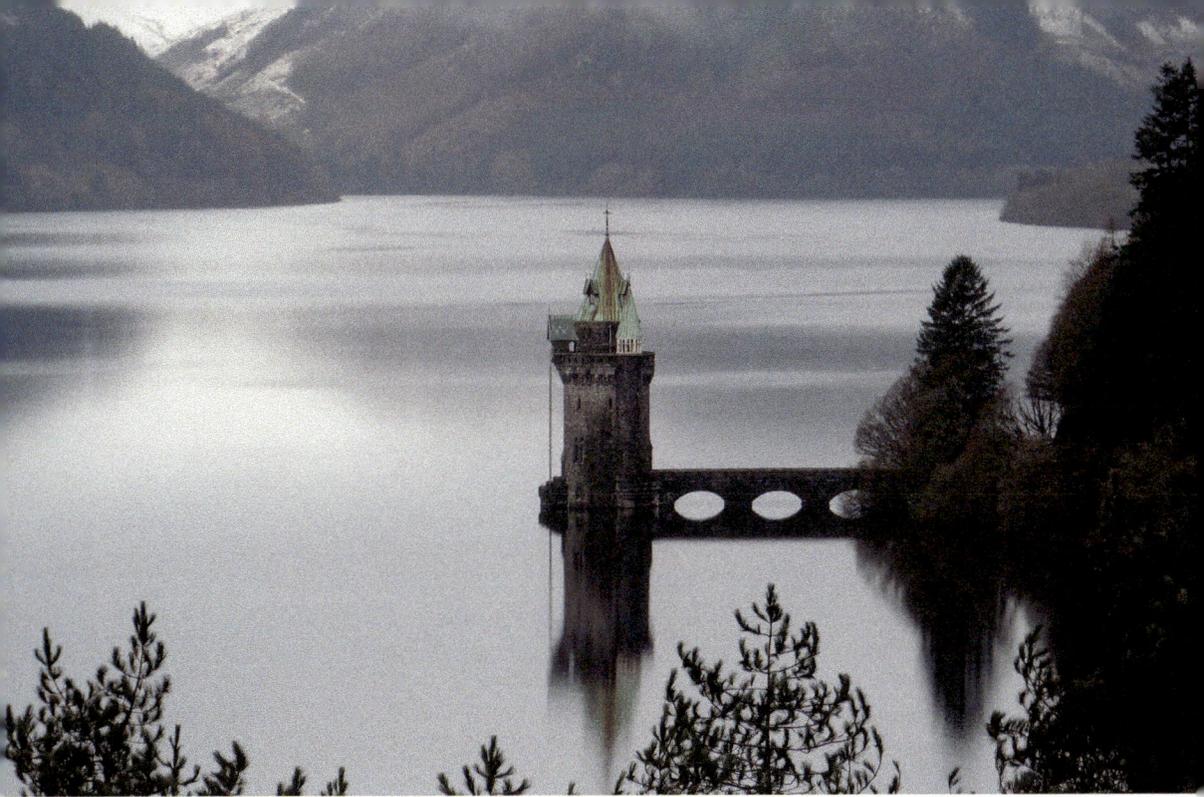

Above: The Straining Tower. (Author's collection)

Below: Overflow. (Author's collection)

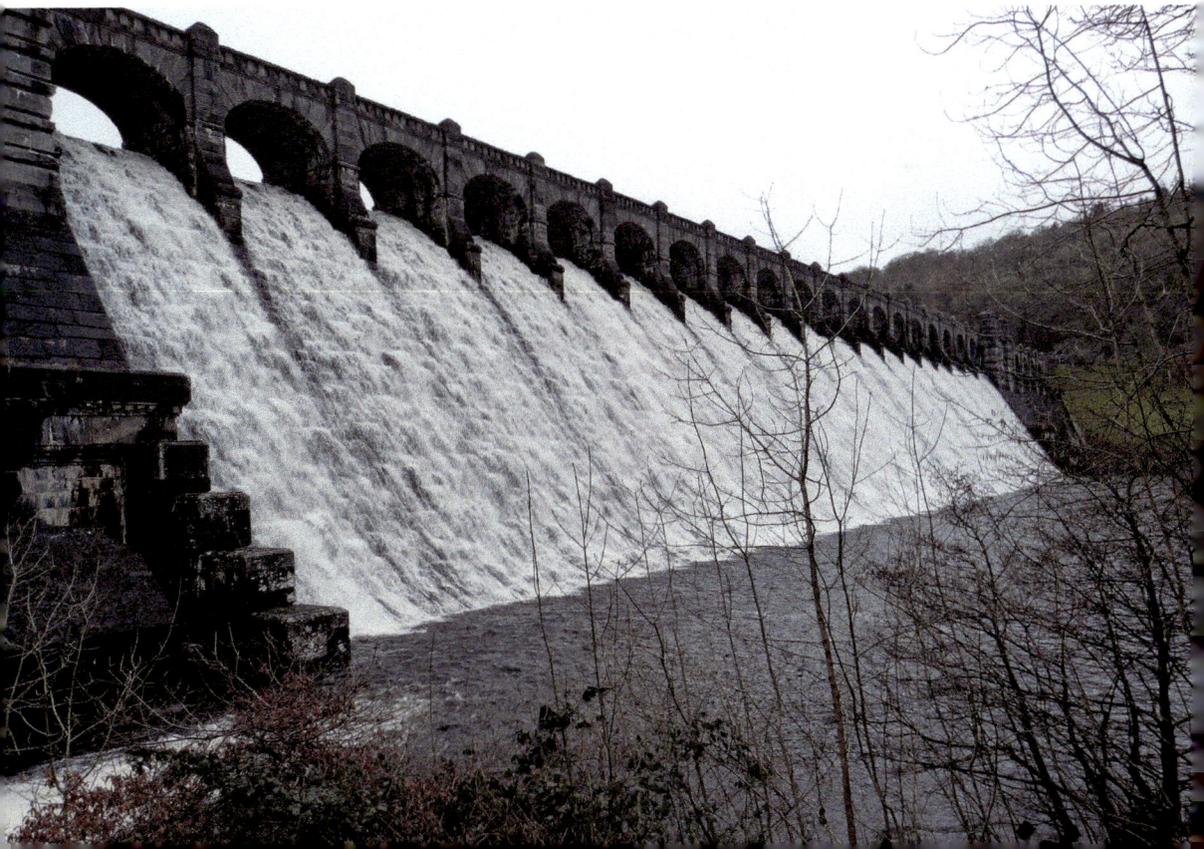

31. Llanfyllin Workhouse

Poor Relief

South-east of Llanfyllin on the A490 there is a notable survivor from our Victorian past – the only workhouse museum in Wales. Once known as Y Dolydd (The Meadow), it had started a long shuffle towards demolition until 2008 when a restoration promoted its re-emergence as a valued museum and a popular Community Arts Centre. But whatever it is now, it meant something entirely different to our ancestors. For them it was a place of shame and fear.

The workhouse was built in response to the Poor Law Amendment Act of 1834 simply designed to save money. Poor relief collected from householders had caused huge resentment, for it was believed to fund the lazy and the work-shy, reflecting the spurious concept of a difference between the deserving and the undeserving poor. The Amendment Act ended any direct financial support and instead the poor had to go to a centralised workhouse.

The Llanfyllin Union covered twenty-three parishes in north Montgomery to distribute the burden more evenly across the county. It was constructed to a national design – a cross with a central octagonal building for the master and matron to assist their monitoring. It cost £7,630 and was completed in 1840. Residents, segregated by gender, were given a uniform and were employed in breaking stones for road repair or recycling old ropes ('picking oakum') for nine hours a day, fuelled by a meagre diet.

Children had a tough time. Separated from their parents, they shared beds in cold dormitories. The stress provoked epidemics of bed-wetting. In 1847 there was a different epidemic: thirty-seven children were affected by scurvy. Their destiny was to be sent to work as soon as possible, the boys as agricultural labourers and the girls as domestic servants.

There was a separate inhospitable block of cells constructed to accommodate vagrants. They were regarded as a threat – as a reservoir of disease and disorder – and yet many of them were merely men looking for work. Such support continued to be offered into the 1970s.

In 1930 the Poor Law system ended and Y Dolydd began a slow and sometimes troubled metamorphosis. It was first a Public Assistance Institution and then a much-loved but financially unsustainable home for the elderly. Its reincarnation in 1982 as an outdoor pursuits centre was short-lived and, when speculators moved in, the fabric crumbled. But thankfully the bulldozers were diverted in 2008 by the Llanfyllin Dolydd Building Preservation Trust. Once it was a 'Poor Law Bastille', that terrible warning brooding ominously at the end of the town. Today it is the final reminder of those forgotten 'prisons for the poor' and we should treasure it for what it shows us.

You can find this thriving and imaginative community resource at postcode SY22 5LD.

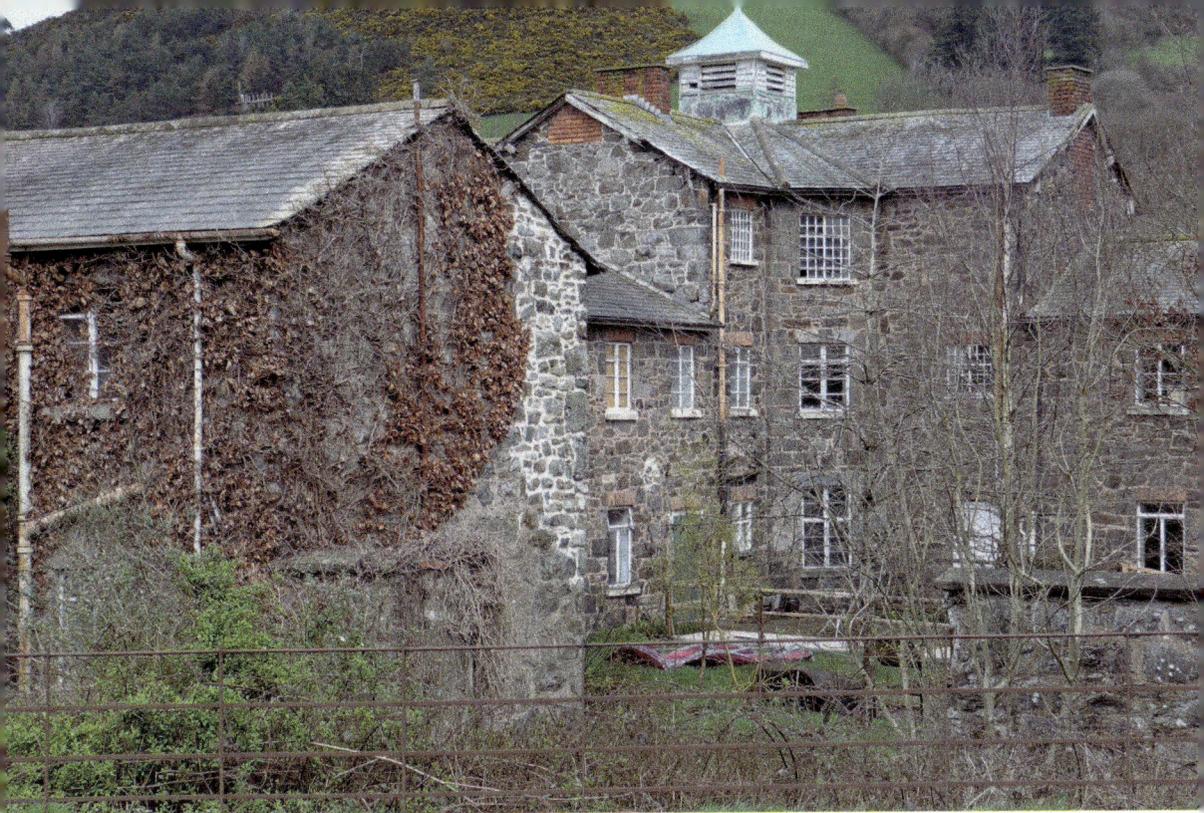

Above: Llanfyllin Workhouse. (Author's collection)

Below: Formerly the Boys' Courtyard. (Author's collection)

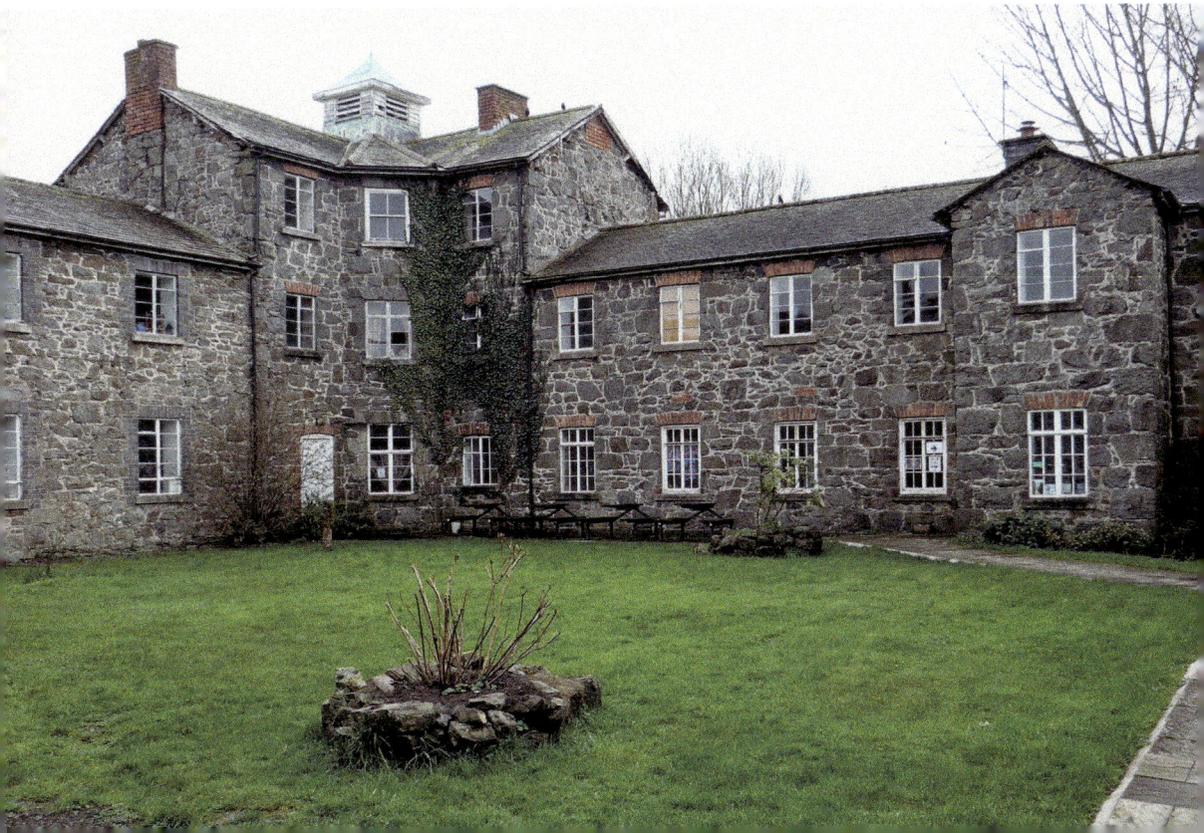

32. Breidden Hills

Trees

Breidden Hills are three separate hills, the remnants of an old volcano. There is Breidden Hill itself, Cefn y Castell (or Middletown Hill) and Moel y Golfa, the tallest at over 350 metres high. They rise suddenly and dramatically from the Severn Plain and dominate the border country to the east between Welshpool and Oswestry. It is a popular place for walkers and footpaths lead up to the summit, where you are rewarded with extensive views of Shropshire and Wales.

In spite of their whale-backed shape, it is odd to think that here, on the lumpy land-locked border between Powys and Shropshire, there could be such a connection with the sea and the Royal Navy.

Rodney's Pillar at the top of Breidden Hill commemorates Admiral Rodney and was built by grateful landowners in 1781 who got rich by supplying the oak for his ships which defeated a French fleet in the West Indies. A pillar with extensive views is very nice in its own way, though perhaps he would have preferred a more portable gift like a carriage clock. Originally it was topped with a 'golden' ball but in 1835 the ball was destroyed by lightning.

Below the pillar there were the Criggion Radio Masts, which the Admiralty once used to communicate with the navy across the world, including the submarine fleet, making Breidden Hill a prime target for Soviet missiles – an incongruous thought for a place so peaceful.

Rodney's Pillar. (Photograph by Chris Newman)

Middletown Hill to the south was the home of Old Parr, who, they said, was born in the reign of Edward IV and by the time of the reign of Charles I was said to be 153. Understandably he was quite a celebrity and the king had him brought to London in 1635. Unfortunately the journey and the bewildering metropolitan environment were too much for him and he died, apparently, of shock, which just goes to show how contrary old men can be. He was buried in Westminster Abbey. Sadly his birth records, such as they were, appear to have been confused with those of his grandfather and he was most probably around seventy. The truth can sometimes disappoint – as did George IV when he was Prince of Wales. He visited his principality just once in 1806 and the spot is marked by the Prince's Oak on the B4393, right on the border with Shropshire, behind Breidden Hill. He fulfilled his obligations by popping into Wales for a convivial glass with his chums beneath the spreading oak (which had obviously escaped Rodney's earlier attentions) before fleeing back to the more familiar thrills of Brighton. It was his only visit.

Postcode SY5 9BA should deliver you close to Rodney's Pillar.

The Prince's Oak in its winter splendour. (Author's collection)

33. Montgomery

All about the Graves

Montgomery is the smallest county town in the country and a pleasant market town with a fine range of distinguished buildings clustering around a neat square beneath the jagged ruins of the castle.

This is border country, just a mile from Offa's Dyke, and the castle was an impressive symbol of power in dangerous times. It was originally a Norman settlement but it was Henry III who replaced the original castle in 1223 with something a little more substantial a short distance away on the huge rocky ridge, to control an important ford over the nearby River Severn and to keep the Welsh in check. It didn't always work.

Montgomery was sacked and burned by Owain Glyndŵr in 1402 but the castle remained intact. It was finally damaged beyond repair by Parliamentary forces in the Civil War, but what has survived remains imposing. Behind the attractive Georgian town hall at the end of Broad Street you can walk up the hill to the castle. The views back down over the town and across to England are wonderful.

The Town Square, Montgomery. (Author's collection)

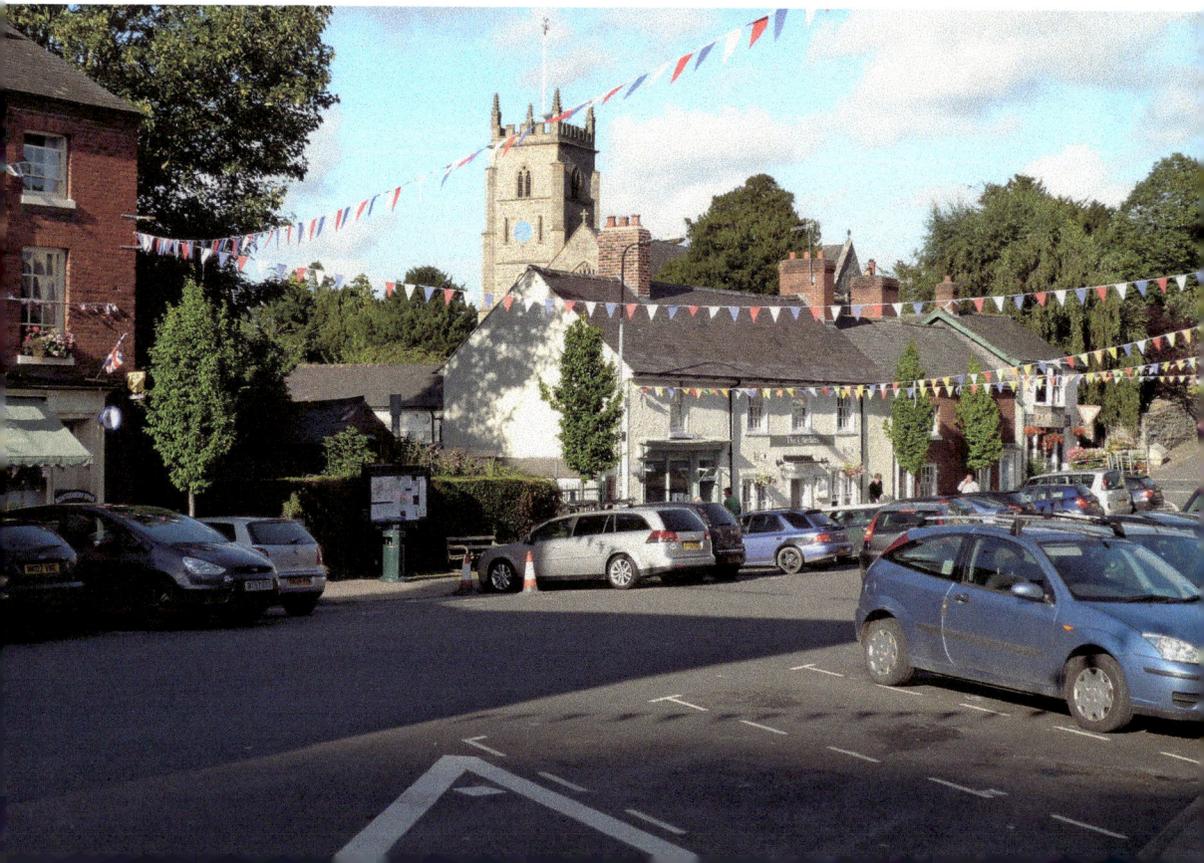

St Nicholas' Church is spacious and has fine features such as the elaborate rood screen, but really it is all about the graves. There is the richly carved Elizabethan tomb in alabaster and painted stone of Richard Herbert and wife of 1600, their eight children kneeling in archways, one of whom is the poet George Herbert. There is also an effigy of Edmund Mortimer (d. 1408), the man who could have been king and who features heavily in Shakespeare's *Henry IV*, Part 1.

Outside you can follow signs to the Robber's Grave. The simple wooden cross represents a notorious story, one of a cursed conspiracy and perhaps divine outrage. John Davies was hanged in front of Montgomery Gaol on 14 September 1821, condemned to death for highway robbery, a crime he did not commit, after two men conspired to frame him. He prayed that God should not allow grass to grow on his grave for a generation as a sign of his innocence.

At the moment of his execution there was a huge thunderstorm, regarded as a clear indication of divine displeasure at the death of an innocent man. In fact, a highly localised storm in Montgomery was reported in the contemporary press. Grass would not grow for a hundred years, even after the graveyard was reseeded in 1851. There is grass there now, in a patchy sort of way.

By the way, St Nicholas is the patron saint of thieves.

Montgomery is south of Welshpool. The postcode is SY15 6PN.

The Robber's Grave. (Author's collection)

34. Knighton

Divorce Court

Knighton is a comfortable town of grey stone in the Teme Valley, straddling the border between Powys and Shropshire. There was once a Norman castle at the top of the hill and you can still see the mound that defined the shape of Knighton with the main street running steeply away from it. Its prosperity has always been based on sheep and it is still a venue for an important livestock market, one which works more conventionally than perhaps it once did. In the early part of the nineteenth century it is said you could get a divorce by selling your wife in the middle of Knighton, a significant collision between rural and urban values even then, representing a radical but unsustainable solution to marital difficulties.

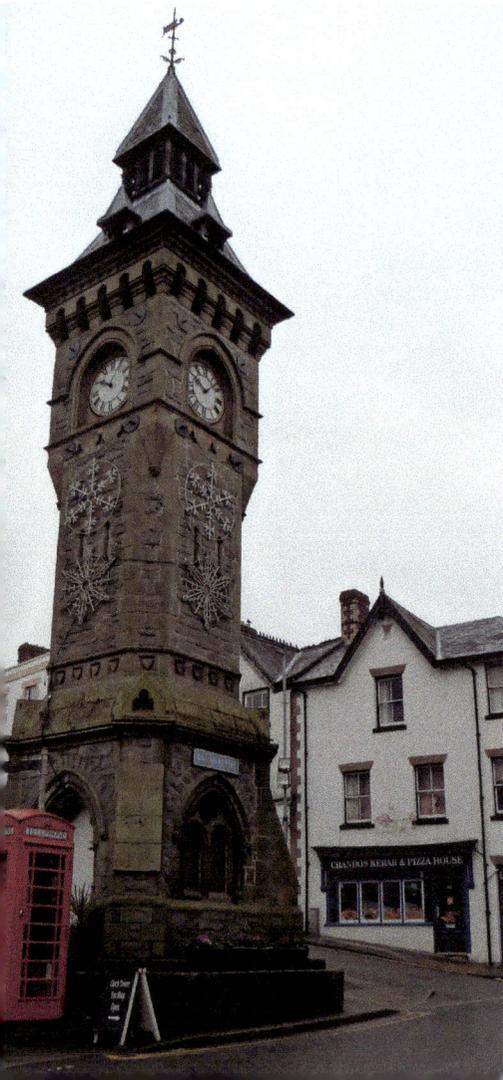

Left: : Knighton's counselling service. (Author's collection)

Below: The plaque was installed in 1971, since when the path has been extended. (Author's collection)

Today Knighton deals with other shattering collisions at the Spaceguard Centre, which monitors asteroids and comets and anything else that may collide with the earth.

There is a healing well here too, once known as St Edward's Well, with a reputation for offering winning cures for aches and sprains, an appropriate therapy because the town is a significant place for those walking the Offa's Dyke Path.

Knighton's Welsh name is 'Tref y Clawdd', meaning 'Town on the Dyke'. In fact it is the only town on the dyke and is the home of the essential Offa's Dyke Centre, where the path was officially opened in July 1971. Most people attempt the path in short manageable sections, which makes Knighton an important hub. It lies around halfway along and offers vital support services to walkers.

There may have been a similar structure in place before Offa told the border communities to get their shovels out towards the end of the eighth century in a restoration project, since keeping the Welsh at bay has a long history. So they created this unique and linear ancient monument, which runs 177 miles from Sedbury on the Wye, north to Prestatyn through stunning countryside. It is 20 feet high in places and sometimes 60 feet wide. It isn't continuous and not terribly difficult for the Welsh to avoid, but it has always defined the almost unchanging boundary of Wales. It is regarded as one of the very best long-distance paths in the world – a true gem.

Knighton is also the starting point for another long-distance path, the Glyndwr's Way National Trail, which finishes in Welshpool. Since the Offa's Dyke Path connects Welshpool and Knighton together, the trails can be combined to form a circular ramble.

The postcode of the Offa's Dyke Centre in Knighton is LD7 1EN.

Offa's Dyke stretches away across nearby Llanfair Hill. (Author's collection)

35. Presteigne

The Law

Presteigne sits on the River Lugg at the point where Shropshire, Herefordshire and Powys meet. A quiet place today perhaps, but it was once busy as the county town of Radnorshire. The river is the border and it wraps itself around three sides of the town, leaving Presteigne rather than like a thumb pushing out into England. It is not surprising that George Borrow described the town as 'neither in Wales nor England, but simply in Radnorshire'.

It has its own quiet attractions but you really should make time to see the Judge's Lodging on Broad Street. It was once the Shire Hall and is now an unmissable museum.

The first Shire Hall had been in poor condition, its structural integrity fatally compromised by the decision to cut a large opening in a wall for access to the town fire engine. A new building opened in 1829. Justice Campbell described

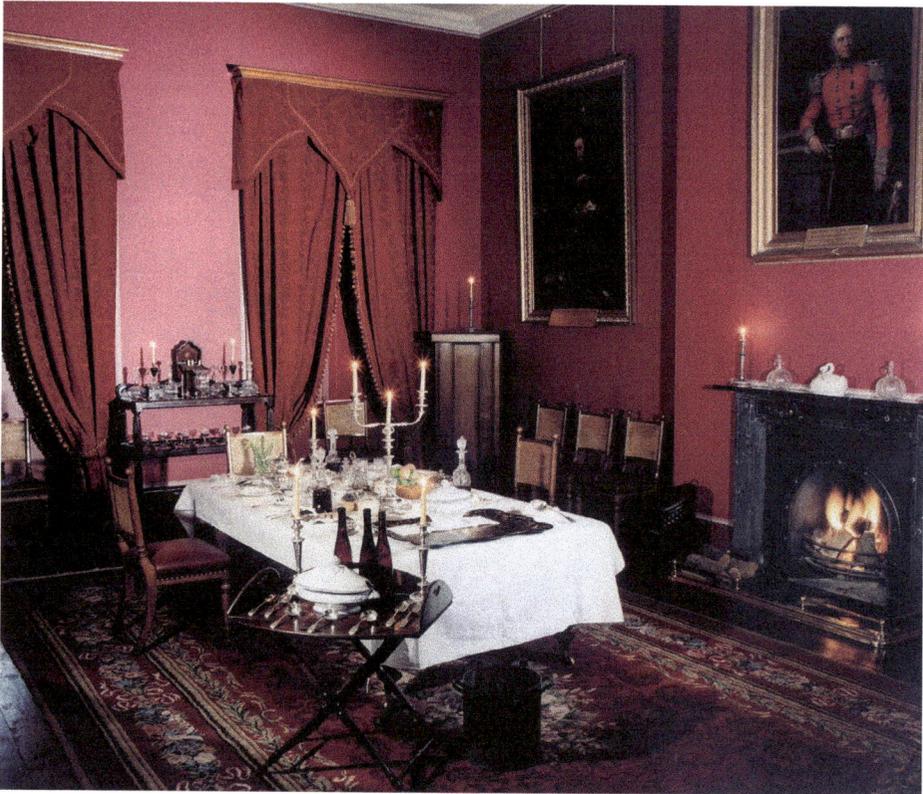

The Dining Room. (Photograph by kind permission of The Judge's Lodging)

the accommodation as the most 'commodious in all England and Wales', but it slowly deteriorated and was eventually regarded as cold and inhospitable. The last court session was held in 1971 and it faced inevitable demolition. However significant and welcome investment, led by Powys County Council and CADW, restored the building to general acclaim. It is now described as a leading Victorian museum and provides an intelligent insight into the nineteenth century. Original features reborn, fireplaces revealed, decorations replicated, furniture restored. The excellent audio tour takes you through the accommodation. You may explore the judge's fine apartments, his library, his furniture and his kitchen.

For some of us it is the servants' area downstairs that draws us to our past, along with the grim reality of the holding cells with their narrow staircase leading you from cramped darkness to the light and space of the courtroom. Many of those who found themselves in those cells would have never been anywhere quite so elegant in all their lives.

You can also see the original gravestone of Mary Morgan. She was executed for infanticide in 1804 when in most circumstances desperate young women like her had such a sentence commuted. It is a shocking artefact; cruel and self-righteous words praising a 'benevolent' judge who was 'eloquent and humane'. You will see a copy standing in the cemetery of St Andrew's Church. But you can also see a small stone facing those cruel words, erected by the angry people of Presteigne themselves, which says so much more: 'He that is without sin among you, let him first cast a stone at her.'

The postcode for the Judge's Lodging on Broad Street is LD8 2AD.

The Court Room. (Photograph by kind permission of The Judge's Lodging)

36. Pilleth

Shakespeare and Mutilation

In spite of the fact that today it is so small, Pilleth, near Knighton, is one of the few places in Wales mentioned in the Domesday Book. The name probably derives from Pwll y Llethr, 'The Pit on the Slope', a reference to the holy well and healing spring in the northern corner of St Mary's Churchyard.

It might also be the site of the battle of Bryn Glas on 22 June 1402, Owain Glyndwr's most famous victory over the English.

The battle was fought on Pilleth's steep slope with the Welsh at the top, releasing a storm of arrows before they charged down the slope to crash into the struggling English. The church, the dividing line between the two forces, was burnt and perhaps 800 English were killed.

Stories are told about the horrible mutilation of the dead by souvenir-hunting Welsh women, a wicked slur Shakespeare was happy to repeat in *Henry IV*, Part 1.

Above the church you will see four wellingtonia trees planted by Sir Richard Green-Price, when drainage work on the hill uncovered bodies of what he believed were casualties in the nineteenth century. Members of his family now rest in the churchyard, along with the ancient dead, acknowledged by an elegant slate memorial.

Pilleth is on the B4356 to the south of Knighton. The postcode LD7 1NP will help.

The wellingtonia trees, commemorating the fallen. (Author's collection)

37. Cascob

Abracadabra

St Michael's Church in Cascob is 5 miles from Knighton, deep in the Radnor Forest, and is a place of secrets. It has an idyllic setting and it is another place with a spectacular yew tree. The church has two interesting memorial panels. One remembers William Rees (d. 1855), who was involved in the revival of the Welsh National Eisteddfod and the other honours Private Edmund Lewis from Cascob, who was 'killed at his work as a prisoner of war in Germany' in 1918.

You are here though to see something exceptional. There is a case on the north wall of the nave that contains a Deed of Exorcism. At the bottom there is the original fragile document and above there is a rough translation from Idris Bell from the British Museum.

It declares, 'I will deliver Elizabeth Loyd from all witchcraft and all evil spirits and from all evil men or women or wizards or hardness of heart. Amen.' There then follows a long prayer to 'turn aside the grasp of the wicked and the malignant'. It proclaims confidently that 'the witches compassed her about but in the name of the Lord I will destroy them'. The document is signed 'Jah, Jah, Jah' and ends in a series of astrological signs.

At the top of the document is a talisman – an 'Abracadabra'. The word is written in full on the top line and then a letter is dropped from the end of the word when it is repeated on each subsequent line until only the letter 'A' remains, forming a triangle.

We know nothing about Elizabeth Loyd or the nature of her demonic possession.

The charm was found in the graveyard and some think it was devised by the Elizabethan magician John Dee who lived in Whitton, but that is hard to support since the charm appears to date from around 1700.

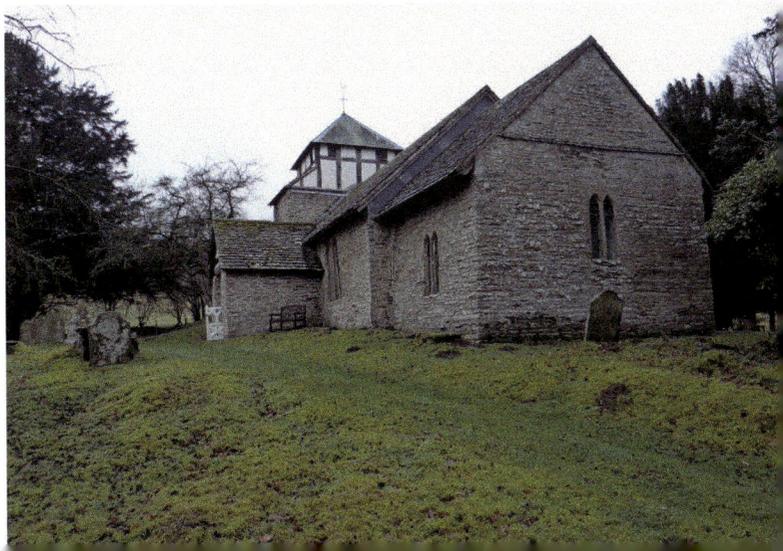

Church of St Michael, Cascob. (Author's collection)

Should you be so inclined you may wish to plot on a map the five churches surrounding Radnor Forest, all called St Michael's. You might then idly connect them by drawing a pentagram and perhaps you will then believe all those rumours: that these churches, along with the strategically placed Cascob Charm, protect the world from a sleeping dragon imprisoned beneath the forest.

They say that an ancient Celtic cross was hidden beneath the churchyard during the Reformation. I don't want you to think I lack imagination but I think that story is more likely than the one about a dragon.

Leave Knighton on the B4355 then take the B4357 through Whitton. Take a signposted right turn to Cascob. The postcode is LD8 2NT.

Left: The Deed of Exorcism. (Author's collection)

Below: Taken from the Deed of Exorcism. (Author's collection)

38. Radnor

Old and New

This is a place for interesting names. You see, there is both Old Radnor and New Radnor and New Radnor itself is old; it is just that Old Radnor is very old indeed.

It is chopped out of a hillside next to the A44, 6 miles south of Presteigne. The surprisingly large St Stephen's Church has a monolithic megalithic stone used as a font, there is a good pub and the place was once the home of King Harold, killed at the Battle of Hastings. No one is really sure where the site of his castle was located. There are a couple of possibilities, but it might have been north of the village at the pleasingly named Castle Nimble.

New Radnor is to the west, 2 miles away, and was established by Harold in 1064 as his new administrative centre. It sits beneath a hill called the Smatcher and the Radnor Forest, which isn't unbroken ranks of trees but reflects the medieval meaning of forest as a hunting ground. The town was laid out on a grid pattern with streets with names like Water Street and Mutton Dingle. Not surprisingly, one has a stream running down it and the other may once have been used by sheep.

In nearby Warren Wood is the waterfall called 'Water Break-Its-Neck', a gentle excursion once very popular with Victorian day trippers. There is a short marked trail you can take from the car park to the fall, which is at its best after rain. Certainly to be recommended.

There was a castle here too, and the motte still dominates the village and offers lovely views if you follow the footpath to the top. It was once an important border fortress that frequently received the unwelcome attentions of Welsh armies. The castle changed hands on twelve occasions during the thirteenth century. It was described as a square structure with three towers, but it has long since gone, along with the town walls.

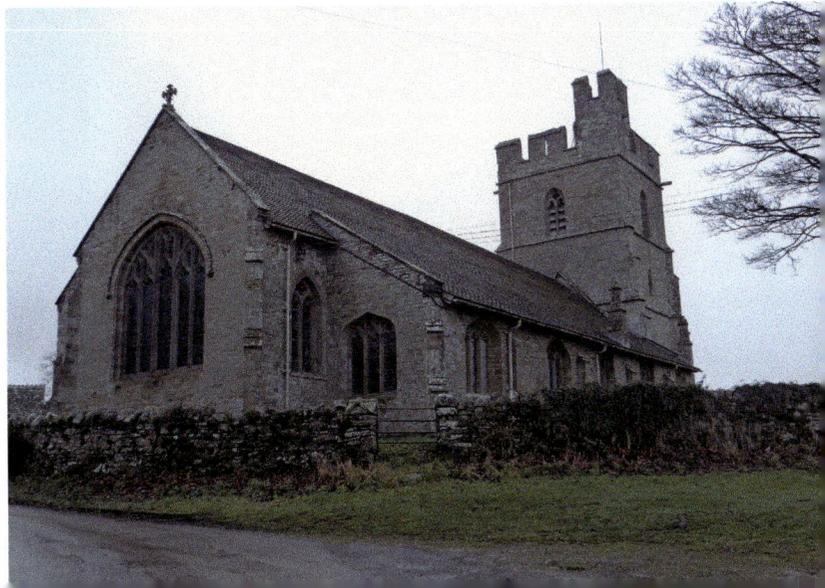

St Stephen's Church, Old Radnor. (Author's collection)

New Radnor has a bizarrely huge monument: the 80-foot-tall octagonal memorial to Sir George Cornewall Lewis, Member of Parliament for Herefordshire from 1855 until his death in 1863. He served in senior government positions like Chancellor and Home Secretary and such was his devotion to his constituents that his family granted them the honour of maintaining this intrusive testament to his ego. The panel in his memory in St Stephen's at Old Radnor is also large but not quite so ostentatious.

The postcode for Old Radnor is LD8 2RH and the postcode for New Radnor is LD8 2TN. You should visit them both.

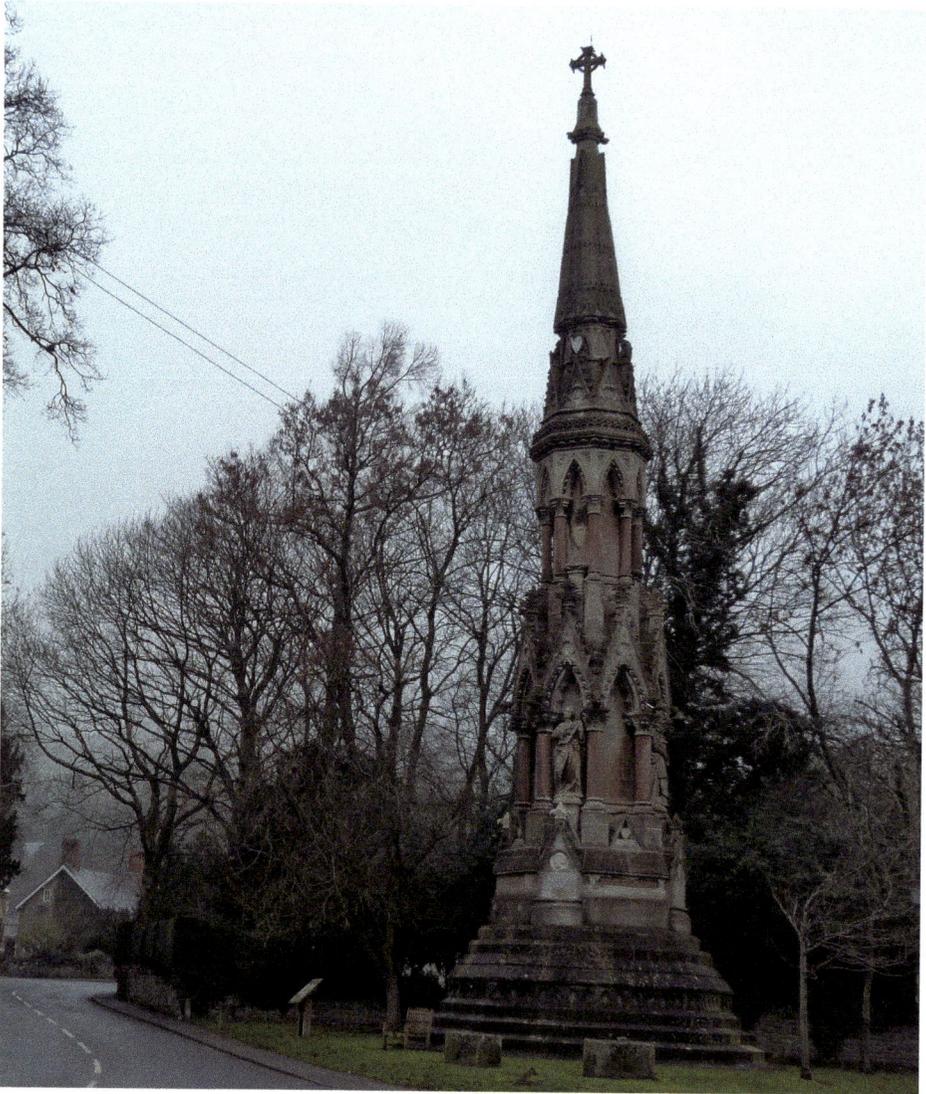

Cornewall Lewis Memorial, New Radnor. (Author's collection)

39. Hay on Wye

Book Learning

You will find Hay on the south-east bank of the River Wye, on the border between England and Wales. It is a location that has given it a lively history. The hilltop castle was a border fortification and often changed hands. It was sacked by King John in 1216 and the ruins you can see are the remains of the keep and the walls built to replace it. Subsequently the Welsh have burnt it down twice and Simon de Montfort had a go at wrecking it too. It has frequently been touched by fire. It was converted into a manor house by the Elizabethans but was twice badly damaged by fire – in 1939 and 1977.

Today Hay visitors can enjoy a pleasant wander along traditional streets. Once there were over thirty-four pubs here but their number is now reduced and opportunities for necessary refreshment are maintained by good coffee shops and tea rooms. Sadly little survives of the medieval walls and its interesting past is overshadowed because today books bring people to Hay. It claims to have the largest collection of previously loved (or second-hand) books in the world, a claim you can test by finding a copy of this book in the town. I am sure you will.

Hay Castle. (Author's collection)

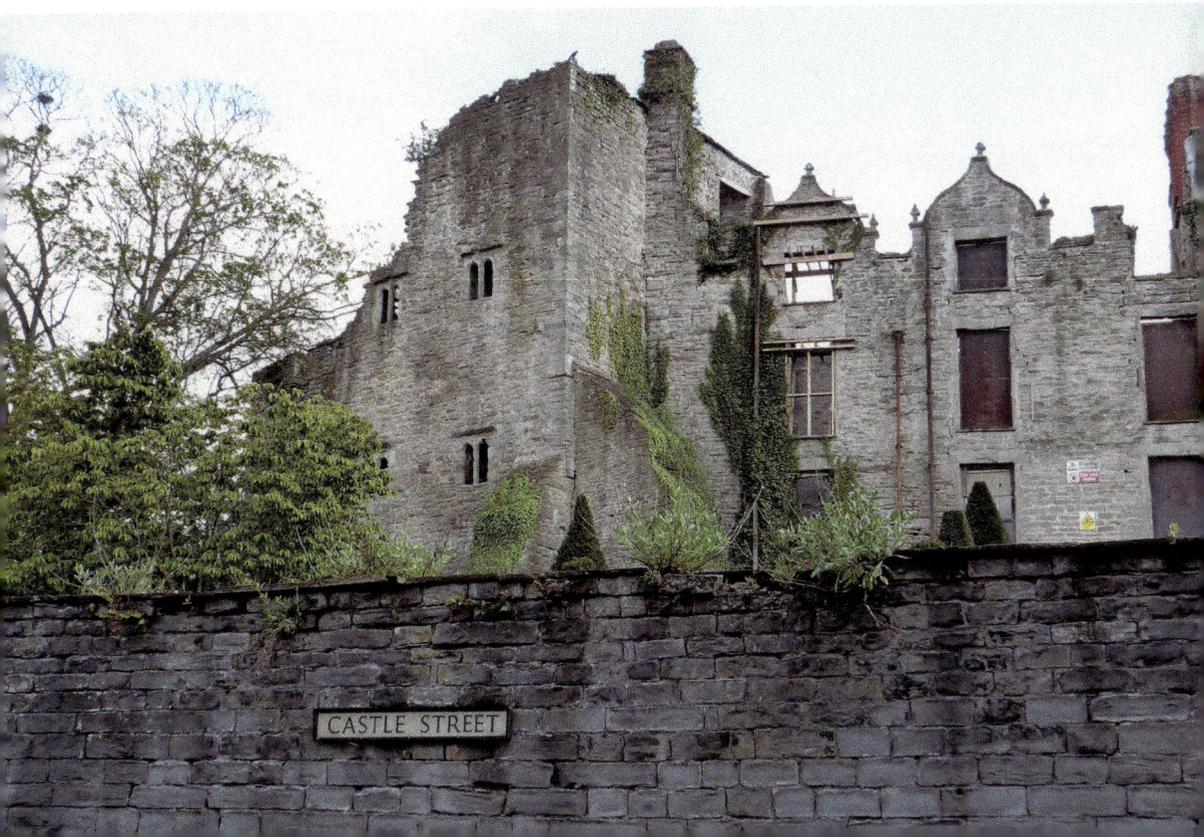

Richard Booth, a local book dealer, annexed a non-existent throne and declared himself 'King Richard Coeur de Livres', with a cardboard crown and a sceptre made from a ballcock, and initially appointed his horse as prime minister. Now he sells honorary positions, knighthoods and passports by post, maintaining the reputation of Hay as a place with character and individuality. It has been an inspired vision and provided a model for a kind of rural regeneration. Now of course there is a world-famous literary festival drawing people from across the world, although almost half of the visitors come from Wales. Bill Clinton described it as a 'Woodstock of the mind', though I think the sheep-speckled countryside around Hay and the mighty River Wye gives it the edge. Like Hay itself the river too has a hidden history. Steeple Pool contains, they say, the old bells of the parish church of St Mary, discarded when it was rebuilt in 1834.

In keeping with its idiosyncratic nature, Hay is twinned with Timbuktu, which has the oldest Islamic library in the world. It is particularly ironic therefore that when Powys County Council drew up plans to close eleven libraries in 2016 in response to an austerity agenda, one of them was the library in Hay, the Welsh Town of Books.

The postcode for the Tourist Information Bureau (and ample parking) is HR3 5DG.

Open-air Honesty Bookshop. (Author's collection)

40. Clyro

Walking, and a dog

Clyro, a mile from Hay, has a surprising and respected place in English literature. It may once have been a Roman fort and there are definitely the vestiges of a Norman castle nearby, but it has two genuine claims to fame. The first is that Francis Kilvert was curate here for seven years, between 1865 and 1872, living in Ashbrook House and recording the details of his life in his famous diaries. And the second? Well that involves a cursed country squire, a gigantic hound and a family called the Baskervilles. You have probably worked it out.

Baskerville Hall is now a hotel but it was once the home of the local landowners who were friends of the writer Conan Doyle, the creator of Sherlock Holmes. During his stays with them he heard the legend of an evil member of their family who was chased to his death by the Hound from Hell. It is said that he refined the idea while walking on nearby Hergest Ridge and thus created Sherlock Holmes' most famous case, first serialised in 1901. The action was relocated to Devon to keep tourists away from Clyro. Today there is more enthusiasm for promoting these connections, rather than keeping them secret.

Francis Kilvert's work is gentler and much less dramatic but it is regarded as one of the most significant of English diaries. On 3 November 1874, by which time he was living in Chippenham, he wrote, 'Why do I keep this voluminous journal? I can hardly tell. Partly because ... I think the record may amuse and interest some who come after me.'

He was right: people have been enchanted by his work, a picture of life in a countryside rivalled only by the work of Thomas Hardy. Kilvert's years in Clyro were probably the happiest period of his life and this is reflected in his work. He is essentially an honest, sometimes unworldly, young man and his accessible writing style allows the reader to see his world very clearly. The diaries are unhappily incomplete, for many volumes were destroyed by his family, but publication of what was to be the three surviving books began in 1938. It was perfect timing – and perfect escapism – taking readers away from a world rushing to war.

His diaries still inspire enormous nostalgia for an apparently easy and simple way of life and enthusiasts wander the area around Clyro tracing his detailed walks through what is now 'Kilvert Country', matching their steps to his and yearning for his vanished world.

The A438 from Glasbury to Whitney goes through Clyro. Alternatively drive just over a mile out of Hay across the river on the B4351. Use postcode HR3 5RZ.

Left: In Clyro. (Author's collection)

Below: Ashbrook House, Kilvert's home, with the Baskerville Arms behind. When he lived in Clyro it was called The Swan. (Author's collection)

41. Llandrindod Wells

Taking the Water

It was just a small collection of three farms, an inn and a chapel at the beginning of the eighteenth century, forgotten amongst the hills. And then they discovered the waters. Of the many healing springs across Wales some are now forgotten – like Llandegley Spa – but the reputation of others has remained intact. Still the most famous of them is Llandrindod Wells, a pleasant and welcoming town surrounded by sheep.

A saline spring had been discovered around 1670 and then a sulphur spring was found where the Pump House Hotel was built in 1749. Another spring was discovered and suddenly Llandrindod had a destiny.

The hotel was initially well patronised, although visitors who came to take the waters upset the local people since 'fashionable gamesters and libertines' have not always found a comfortable welcome in Llandrindod. The hotel was eventually demolished in 1787.

However, the arrival of the railways in the 1866 transformed the town. Thousands of visitors could now access Llandrindod Wells easily and they came to take the waters. This caused a huge surge in property development, out of all proportion to the size of the local population. That is what makes the place such a surprising place today. It looks as if a London suburb, with additional architectural extravagances, has suddenly been relocated to the middle of Powys. You can see fine Victorian terraces, sometimes built with five stories to accommodate 80,000 visitors (and their servants). The town was keen to provide 'accommodation for the invalid of whatever rank and distinction', but although they had the very same water in the Pump House, there were two tariffs – for first- and second-class visitors. Same water. Different glass.

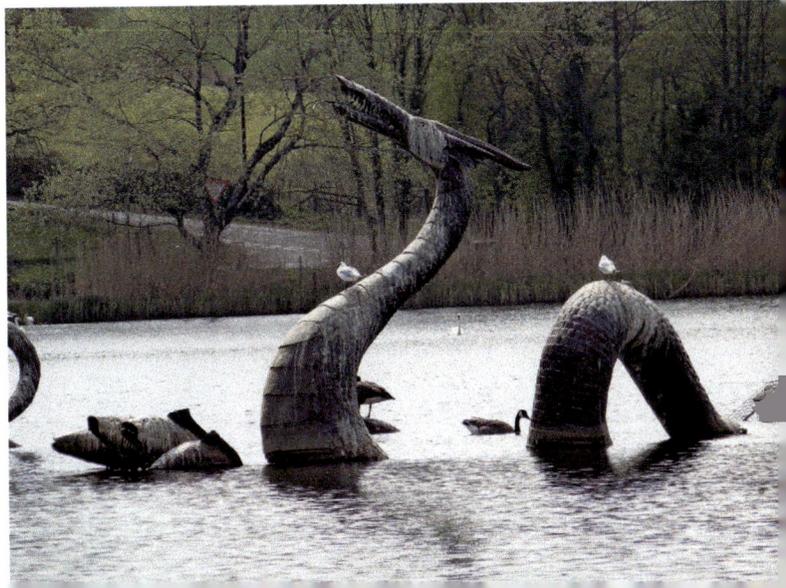

A dragon takes the water at the Lake. (Author's collection)

Taking the waters is no longer fashionable but Llandrindod is still a place to be enjoyed. There are parks and gardens and there is plenty of space. It is proud of its past – after all, the town crest features Hygieia, the goddess of health.

You can still try a glass of the water at the Chalybeate Spring in Rock Park and if you do, you might find it hard to believe that there would sometimes be queues 2 miles long waiting to drink this rather unpalatable medication. The saline spring was 'laxative, diuretic and alterative' while the sulphur spring could just about cure anything, although the advice was not to take it in the afternoon due to its rather brisk purgative effect. A guidebook in 1897 felt it necessary to suggest a measured approach: 'Better stay at home than subject one's organisation to the careless use of these waters.' Wise words indeed. I have always supported the idea of an untroubled organisation. Use postcode LD1 5DY.

The library. (Author's collection)

The Chalybeate Spring. (Author's collection)

42. Abbey Cwm Hir

Ruins in the Grass

It was once a Cistercian abbey, founded in 1143, and the largest abbey in Wales despite the fact it was never actually finished. The Cistercians always built in secluded places. This is no different. It feels remote, almost other-worldly.

When you walk amongst the ruins you will find a peace that you can touch, a silence that embraces you. There are incomplete walls, fragments scattered at random across the site. Where the High Altar may have been there is now a memorial slab, marking, perhaps, the grave of Llewelyn ap Gruffydd, the last true Prince of Wales. This is where tradition says his headless body was put to rest after his assassination at Cilmeri (see entry), although in the nineteenth century they believed he was buried where he fell, either at a crossroad or in a farmyard. Perhaps a slab in a ruined abbey is as good a place to remember him as anywhere. Today the clear outlines of this modern tribute stand in sharp contrast to the blurred ruins in the grass. It is a reminder of the dismal reality of political history amongst this gentle landscape, with sheep in the fields and fish in the stock pond.

The ruins of Abbey Cwm Hir. (Author's collection)

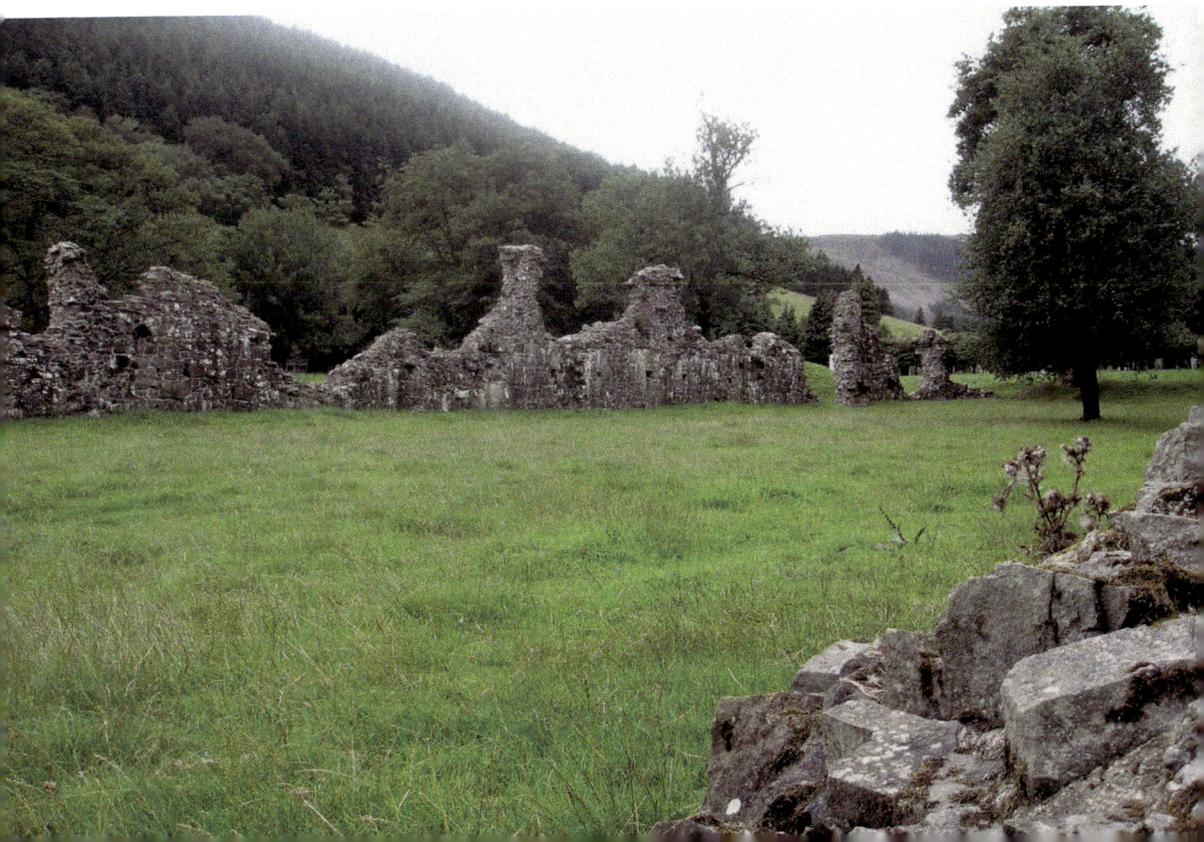

The abbey was founded in 1143 with monks moving here from Whitland and appears to have survived the horrendous slaughter of Llewelyn's army on 12 December 1282. They camped here waiting for his return and were taken unaware early in the morning. Contemporary sources suggest there were over 3,000 Welsh dead and not one English casualty.

The abbey was finally destroyed when it was ransacked by Owain Glyndwr's forces, who believed that the monks were English spies in 1401 and it was reduced to ruins in 1644 during the Civil War. Material from the abbey has always been used in the building of local houses. You can still see the arches from the nave in Llanidloes. When monasteries were dissolved in 1536 they were incorporated into the parish church of St Idloes (see entry.)

There is a lovely hall in the village, built in 1833 in an Elizabethan style, which is now open to the public, the attractive Church of St Mary and a traditional pub called 'The Happy Union', which has a sign featuring, bizarrely, a Welshman sitting on a goat. But it is probably the ruins that will bring you to here, and you will find it hard to reconcile its brutal history with the tranquility that surrounds you.

On the A483, north of Llandrindod Wells, there is narrow road to Abbey Cwm Hir which follows the Clywedog Brook. Use postcode LD1 6PH.

The memorial to Llewelyn ap Gruffydd. (Author's collection)

43. Llanafan Fawr

Silent Witness

In Llanafan Fawr on the B4358 between Newbridge and Beulah you will find the Red Lion Inn, one of the oldest pubs in Wales dating perhaps from at least 1188. But it is not the oldest thing in the village.

Behind the inn there are the remains of an Iron Age encampment, and St Afan's Church across the road was built on top of an Iron Age mound. Everything however is predated by the real gem: a magnificent yew tree estimated at over 2,300 years old and one of the oldest in the country.

That yew has been a silent witness to so many things, like the death of St Afan, killed by a Viking raiding party in the sixth century in a meadow next to the River Chwefru below the church. The spot is marked by an impressive standing stone. His tomb is to the right of the porch.

The yew was also there when an unusual gravestone was erected around 30 metres from the porch. Not only does it have the name of the man who died, but also the name of his murderer. 'John Price who was murdered on The Darren Hill in this parish by R. Lewis April 21, 1826.'

Who knows what other lost mysteries that tree has seen.

Use postcode LD2 3PN.

The yew tree, a silent witness to 2,500 years of history. (Author's collection)

44. Builth Wells

The Royal Welsh Show

The town sits in a scenic position where the Irfon meets the Wye. However, the ravages of history have given it a rather undistinguished air, but then it has had a tough time. An outbreak of the Black Death in 1350 led to the complete isolation of the town, with the payment for provisions from outlying areas left in the water of a stream which is still known as Nant yr Arian (the Money Brook). In the late seventeenth century at least forty houses were destroyed in a fire and then rebuilt with stones from the crumbling Norman castle, which has now disappeared – as a separate building anyway. In later years visitors came to sample the mineral waters but Builth was the least successful of the Welsh spa towns. In 1820 a guidebook noted 'There are three springs of different qualities ... but owing to the carelessness of the workmen employed to erect a house for the visitors the waters have been mixed and are now little frequented.'

However Builth holds a very important place in the Welsh consciousness because it has been the permanent headquarters of the Royal Welsh Show since 1963, although technically the showground is across the river in Llanelwedd. The show consistently attracts almost a quarter of a million visitors over its four days in July, who come to enjoy this vibrant expression of Welsh rural identity. The Royal Welsh Agricultural Society exists to encourage agriculture throughout the country and is dedicated to improving the breeding of stock and to eradicate disease. It supports forestry and conservation and encourages the next generation to commit their futures to the land. The show is intended to showcase the best that Wales can offer and provides demonstrations of innovations and farming methods.

It clearly has a noble mission but while the promotion of business and education is vital for the long-term preservation of our special landscape, the show is also a fun place to be. It is a great social occasion, bringing people of all ages together from their widespread communities. There are competitions, activities, displays; it is a heady mix of chickens, horses, sheep shearers and tractors. The popular Food Hall offers an opportunity for cheesemakers, brewers and gourmet sausage artisans to showcase and sell their produce. It is why some people return year after year, their enthusiasm undimmed by unpredictable Welsh weather.

This annual reaffirmation of rural life is justifiably described as 'the pinnacle event in the British agricultural calendar'. It is deservedly one of the gems of Mid Wales, bringing sheepdog trials to the people every year.

The postcode for the showground is LD2 3SY.

Above: By the Wye in the centre of Builth. (Author's collection)

Below: The Main Ring at the Royal Welsh Show. (By kind permission of the Royal Welsh Agricultural Show)

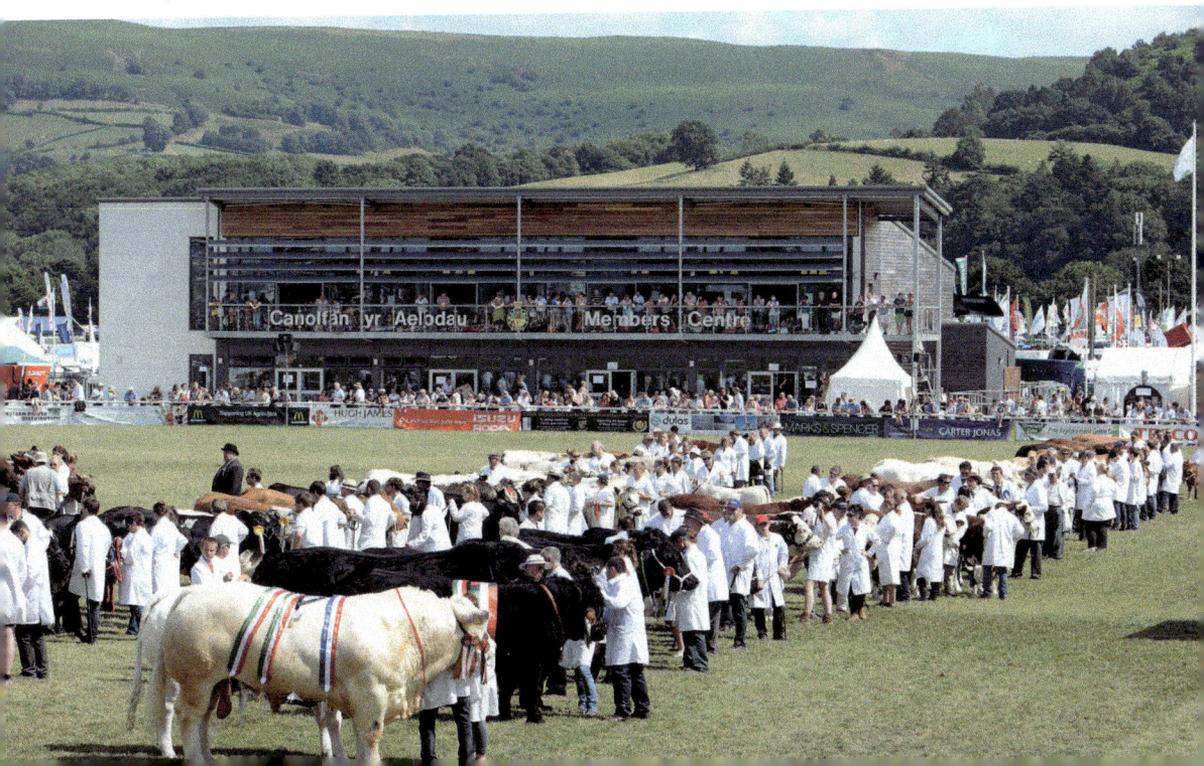

45. Cilmeri

Murder

In Cilmeri there is a simple stone on a mound commemorating a turning point in Welsh history. During an insurrection Llewelyn ap Gruffydd, the last native prince of Wales, left Snowdonia, believing that some of Edward I's forces were ready to defect to him. His army waited at Abbey Cwm Hir while he left with a small bodyguard for secret negotiations. It was an elaborate assassination plot. The Welsh were ambushed and killed at Cilmeri in the late afternoon of Friday 11 December 1282.

It is believed that Llewellyn died when Adam of Frankton ran him through with a lance before he was beheaded. In the corner of the site there is a flight of steps to the well where they might have washed the severed head. It was eventually taken for display at the Tower of London, where it remained for fifteen years.

The standing stone, a piece of granite from Caernarfon, was erected in 1956, and every year on the anniversary of his death patriots meet at Cilmeri to mourn him, fearing that the dream of an independent Wales may have died with him on that winter's afternoon all those years ago.

The monument is on the A483 between Builth and Llanwrtyd Wells runs through Cilmeri. The postcode LD2 3NU should help.

Where patriots meet in Cilmeri. (Author's collection)

46. Llanwrtyd Wells

Bog Snorkelling

Llanwrtyd Wells calls itself either the smallest town in Britain or the 'Capital of Weird', but it wasn't always like this. At the height of the Victorian enthusiasm for healing mineral waters it became one of the four important spa towns of Mid Wales.

Its reputation as a medicinal spa began in 1732 when the local vicar, Theophilus Evans, watched a frog swimming in the waters of a spring called Ffynnon Ddrewllyd, or 'stinking spring', because it was rich in sulphur. Eighteenth-century vicars found time for such things. The brave man tried the waters himself and soon reported that he was miraculously cured of scurvy. This established Llanwrtyd Wells as an important spa resort and transformed this quiet green-wrapped town.

Leigh's New Picture of England and Wales (1820) described the waters as 'extremely efficacious in scorbutic and scrofulous complaints … at the spring is a handsome house and a commodious warm sulphur bath for the convenience of visitors'. Later provision was sometimes supplemented by water brought from the saline spring in Builth Wells.

Visitors increased with the arrival of the railway. The posh went to Llandrindod Wells, royalty went to Llangammarch Wells to take the barium spa waters (Kaiser Wilhelm II visited in 1912), but throughout the history of Llanwrtyd Wells its visitors were generally Welsh-speaking. The clean, fresh air of Mid Wales was especially attractive to those from industrial South Wales, for the town was easily accessible. At its peak up to eighteen trains a day arrived at the local station.

There were four spas within the town, though they fell into disrepair when enthusiasm for mineral water began to fade. One of them, the Abernant Lake Hotel, was used by the Czech government-in-exile as the first free Czech school for refugee children. But the wells are no longer in use.

Eventually economic diversification for Llanwrtyd Wells emerged at the Waen Rhydd bog, where competitors, often in fancy dress, swim up and down a trench hacked out of a peat bog, cheered on by drinking relatives. Llanwrtyd Wells is indeed proud to be the home of Bog Snorkelling, an excuse for an all-day party, with mud. There is also the unmissable annual Man versus Horse Marathon. In 2012, annoyed that it had been inexplicably ignored as an Olympic venue, the town began the 'World Alternative Games', a celebration of unusual sporting events including Office Chair Racing and the Wife-Carrying Championships.

Frog watching is probably still popular but remains a more solitary pursuit.

Llanwrtyd Wells is on the A483 between Llandovery and Builth Wells, postcode LD5 4RB.

Above: The River Irfon. (Author's collection)

Left: *Spirit in the Sky* by Sandy O'Connor , in the middle of Llanwrtyd Wells. (Author's collection)

47. Brecon

Pub Signs

You can scoot around on the bypass of course – many people do – but Brecon isn't a place that should be overlooked. There is plenty of parking and plenty to see.

Brecon has a long and distinguished military past, beginning with the Romans. Their fort, Y Gaer, 3 miles west of the town, was the home of a Spanish cavalry troop and the grassed ramparts still give a strong impression of its original size. The Normans built a castle where the River Usk could be easily forded and where it meets the River Honddu and it inevitably became an administrative centre as well as a military stronghold.

In the thirteenth century it was attacked by the Welsh on six occasions and they achieved a reasonable 50 per cent success rate. Not surprisingly the residents became irritated by all the mess and disruption such aggression implied. During the Civil War they took matters into their own hands and confirmed their neutrality by demolishing much of the castle and the town walls, thus reducing its attraction to either side. The ruins of the castle can still be seen in the grounds of the Castle Hotel and next door in the Bishop's Garden.

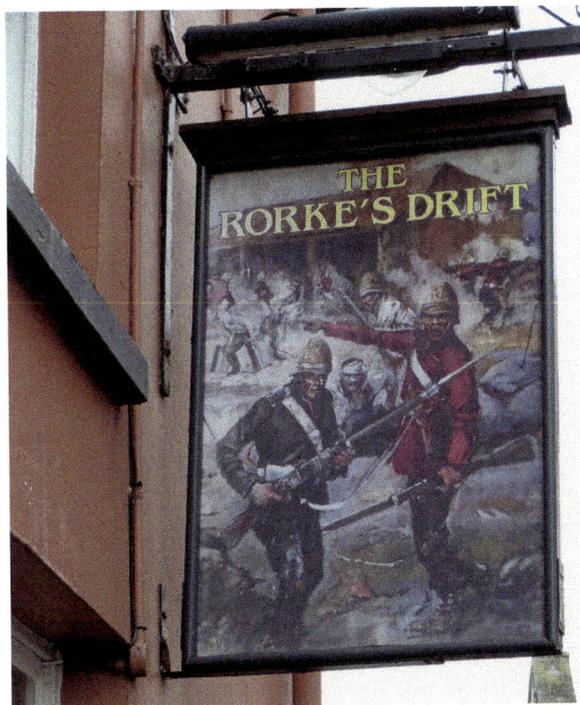

The Rorke's Drift.
(Author's collection)

The South Wales Borderers were based in Brecon and they were involved in the famous colonial engagement in January 1879 at Rorke's Drift, when 140 Borderers successfully resisted an assault by over 4,000 Zulu soldiers and were awarded eleven Victoria Crosses and other honours and decorations.

Another VC winner is remembered in Brecon too. Captain Charles Lumley was awarded the medal for his bravery during an assault at Sebastopol during the Crimean War in 1855, when he was badly wounded in the mouth. Poor Charles tragically shot himself in the toilet of the barracks in Brecon in October 1858 and is buried in a chest tomb in the north-east corner of the cathedral churchyard.

It isn't just military attractions here though. The fine Brecknock Museum and Art Gallery is certainly worth a visit and occupies a Grade II-listed building, the old Shire Hall, in the middle of the town.

The town was also the birthplace of the actress Sarah Siddons (1755–1831). Her birthplace was a pub called The Shoulder of Mutton. Now it has been renamed, more appropriately perhaps, in her name. Joshua Reynolds painted a famous portrait of her, which he called *Mrs. Siddons as the Tragic Muse*. A short distance away there is the Rorke's Drift pub – in Brecon they have a convivial way of celebrating their past.

You can find the Tourist Information Centre in the Cattle Market car park. The postcode is LD3 7DP.

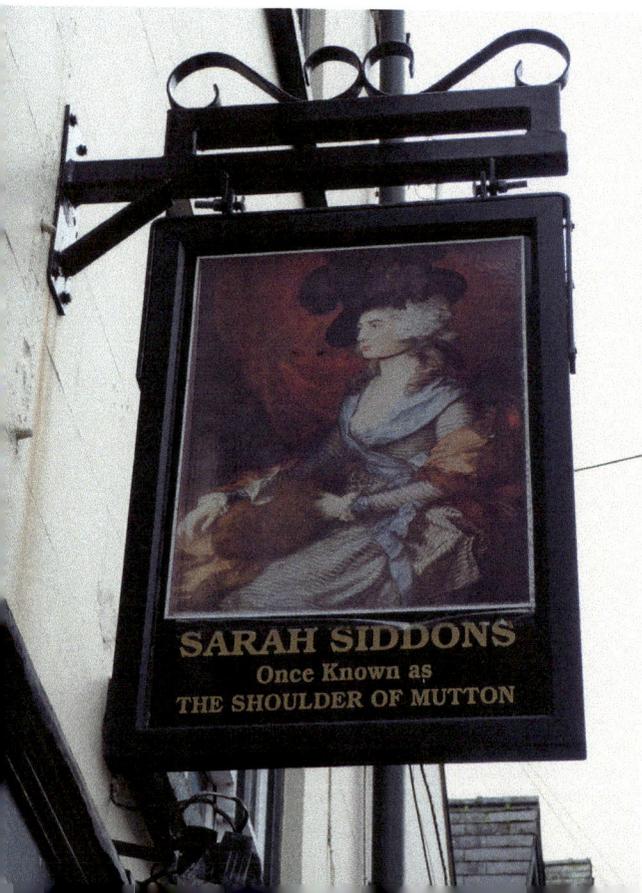

Sarah Siddons. (Author's collection)

48 Partrishow

Doom

The Church of St Patricio has considerable beauty and is a considerable gem. It is in the south of Powys to the east between Abergavenny and Crickhowell. The church seems lost amongst the hills and the trees but as a result escaped the full attentions of the Reformation. Everything seems soothingly peaceful and when you enter the church you are instantly transported deep into the past.

It was consecrated in 1060 and the massive font probably dates from 1055. The inscription says that it was 'made in the name of Genillen', who was a prince of Powys before the Norman Conquest. You can also see beautiful carvings, especially the loft and the screen, which depicts in one corner the eternal struggle between good and evil, represented by a fierce dragon consuming the vine of growth and hope.

On the west wall of the nave is a medieval painting in red ochre of a skeleton holding an hourglass, spade and scythe. This is a 'Doom Figure'. Before the Reformation such pictures were displayed as a reminder to simple worshippers that our days are numbered and that we must use them wisely.

The image was later covered in whitewash and replaced with biblical text, but 'Doom' is eerily reappearing from beneath, like an image of death caught on a medieval security camera.

The Church of St Patricio. (Author's collection)

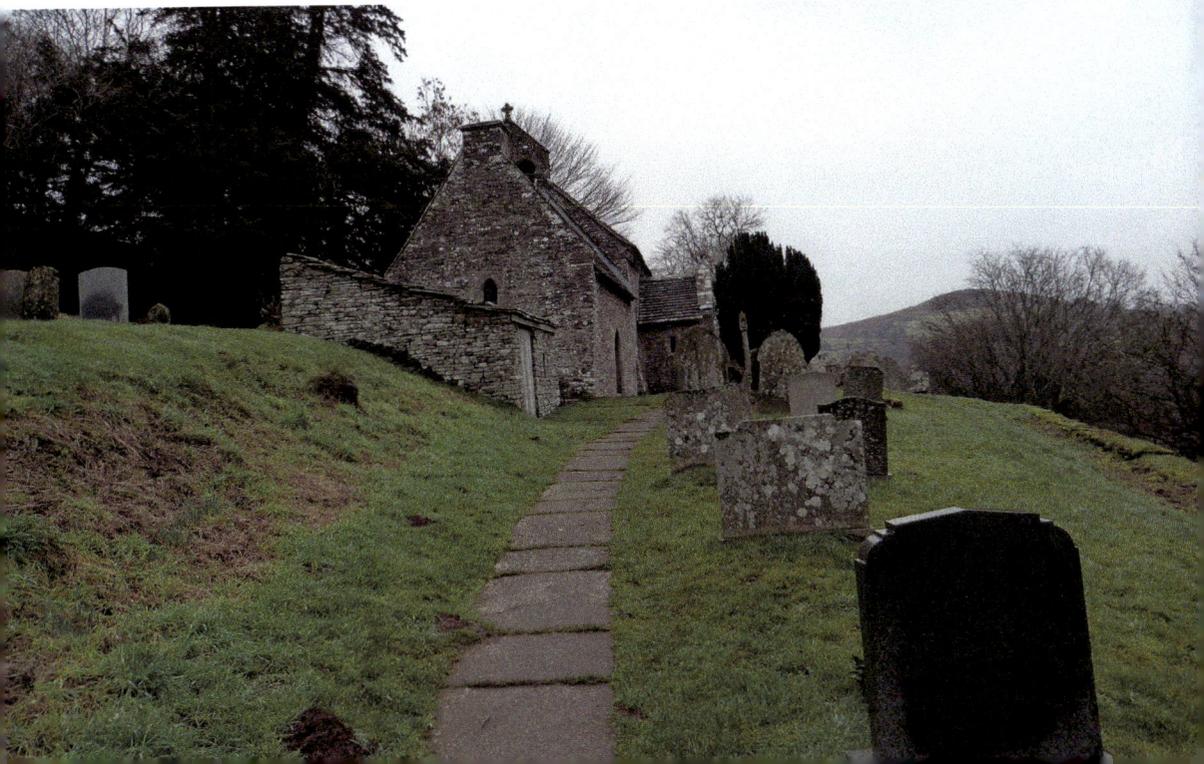

The room at the west side is the hermit's chapel. Saint Issui may lie under the altar and at the bottom of the lane you can find his well, Ffynnon Issui.

Saint Issui was a sixth-century hermit who used the water to baptise local people. The well became a place of pilgrimage after Issui was robbed and murdered by a traveller seeking shelter but who refused to accept Christianity. Soon the well was believed to have healing properties and the legend is that a pilgrim cured of leprosy left a bag of gold which paid for the building of the church. More modest offerings like shells and, oddly the last time I was there, a hair brush are still left by visitors.

At Llanvihangel Crucorney take the B4423 next to the Skirrid Inn. At Stanton take the signposted lane to the left – it gets narrow but hold your nerve and keep following the signs. At some point you will cross into Powys. Eventually a sign takes you uphill to the right and you will find the church sitting above a valley on the right-hand side. There is a small parking space. You can get there from Crickhowell and follow signs from Llanbedr but the lanes are equally demanding. However you do it the drive is worth it.

The postcode is NP7 7LP.

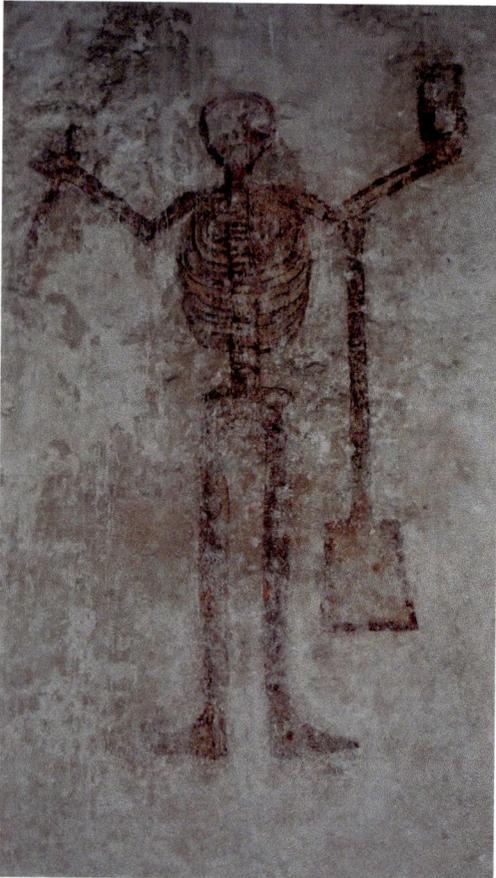

The Doom Painting. (Author's collection)

49. Pontneddfechan

Waterfall Country

This is a unique place offering a striking contrast between destruction and beauty. After all, Pontneddfechan once had the only gunpowder production facility in South Wales. The works began as the Vale of Neath Powder Co. in 1857 and eventually became part of Nobel's Explosives Co., producing gunpowder for use in mines and quarries. It was an extensive site, with widely separated buildings to limit the effect of explosions. The site was abandoned in 1940 and there is the signposted Powder Walk, which takes you through these atmospheric ruins. But most people come here because Pontneddfechan is the gateway to a secret, for this is known as Waterfall Country. To the north towards Ystradfellte and Brecon, the water has cut through the limestone to create deep wooded gorges and spectacular scenery, with what is regarded as the best series of waterfalls anywhere in the country.

Given the beauty of these falls it is a surprise that they have remained relatively unvisited, but that might reflect the fact that they require a determined and occasionally challenging walk to reach them – but it is undoubtedly worth the effort. You will need a good map because there is so much to see on three separate rivers. There are car parks at strategic points throughout the area but you should not attempt a visit without either appropriate footwear or a mobile phone – just in case. You have to be careful along the paths and by the water of course. But signs like 'deaths have occurred' do help to focus the mind.

You should start upstream at Porth yr Ogof just below Ystradfellte. From the car park you can scramble down a steep and rocky path, slippery when wet, to where the River Mellte disappears underground for 250 metres into a mass of passages and caverns through the largest cave entrance in Wales. It is dark and mysterious, a portal to another world.

Once it emerges, the magical Afon Mellte runs into the most northerly fall at Sgwd Clun Gwyn, which leads to Sgwd Y Pannwr and then on to the confluence with the Afon Hepste. Here you can turn upstream to follow the noise of the thunder of Sgwd yr Eira (Fall of Snow), where you can walk behind the tumbling water.

Back in Pontneddfechan the Mellte is joined by the Afon Nedd Fechan, on which there are three waterfalls and on the Afon Pyrddin, which runs into it, you will find the elegant Sgwd Gwladus. There is such a great deal to see here that it can become quite confusing, but the beauty of this dramatic river scenery in isolated woodland is undeniable.

Pontneddfechan is located on the B4242 at the end of the Neath Valley. It is signposted from the A465 at Glyn Neath. Use postcode SA11 5NR.

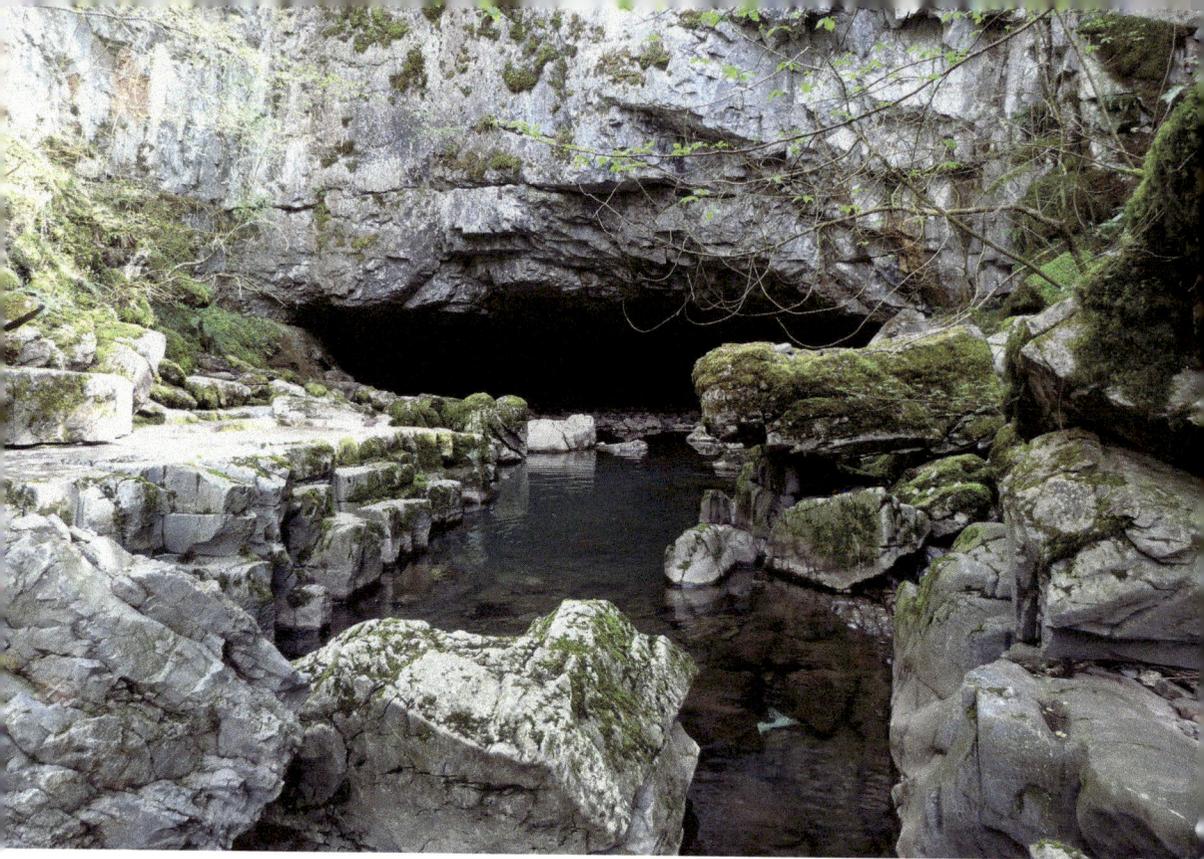

Above: Porth yr Ogof. (Author's collection)

Below: Sgwd Clun Gwyn. (Author's collection)

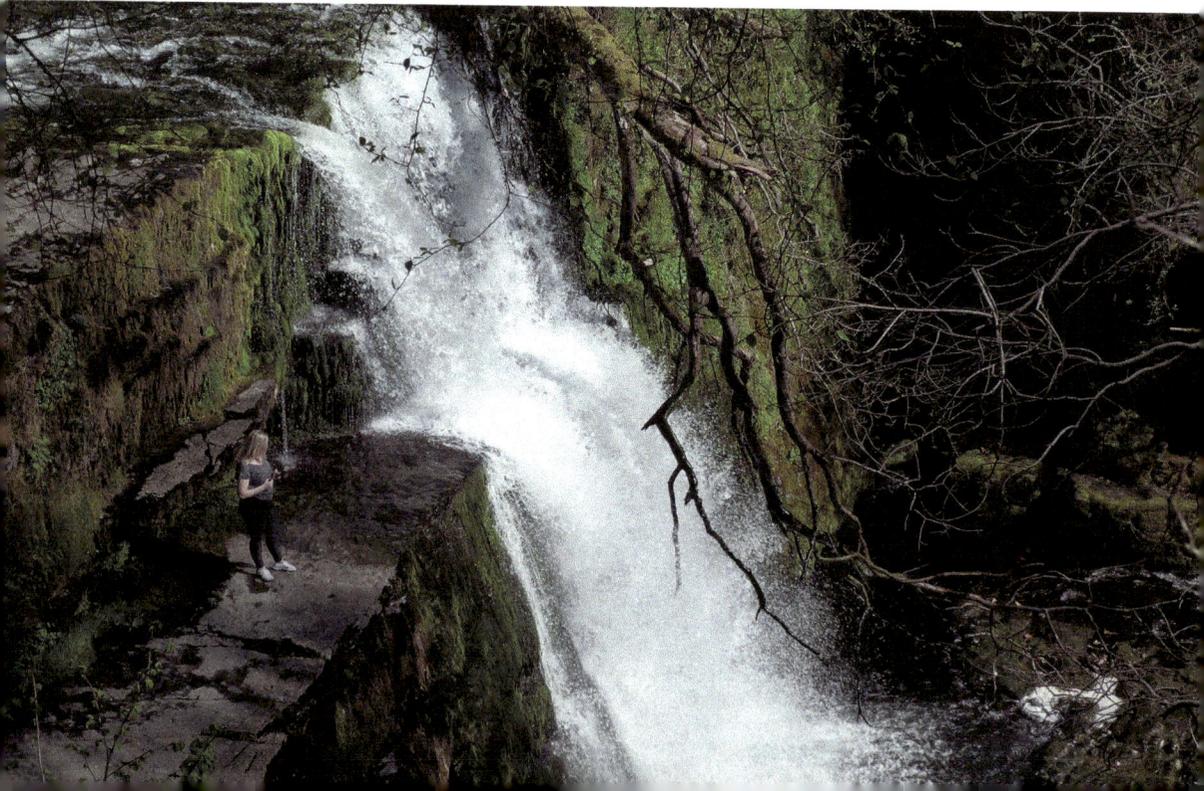

50. Dan yr Ogof

A Natural Wonder

Known as the National Showcaves Centre for Wales, Dan yr Ogof is a 17-km-long cave system, voted the greatest natural wonder in Britain and certainly a major tourist attraction.

The first section of three caves is open to the public, but behind them is an extensive system, not yet completely explored, which is a national nature reserve. It is considered to be one of Europe's largest cave complexes. In Dan yr Ogof itself there are extensive and attractive passageways while in Cathedral Cave you can walk behind cascading waterfalls. In Bone Cave extensive Bronze Age human remains have been found.

The existence of the cave was known of course, as you can see in the name Dan yr Ogof, which means 'Under the Cave', but it wasn't properly explored until 1912 when local farmers, the Morgan brothers, tracked the water that was coming onto their land back to an extensive confusion of caves. They took with them some simple equipment and an old revolver since they had no idea what they might have to face. Initial explorations were halted by a large lake but they later returned to cross it in a coracle.

Original photography by GeoPictures.net. (Nat Showcaves)

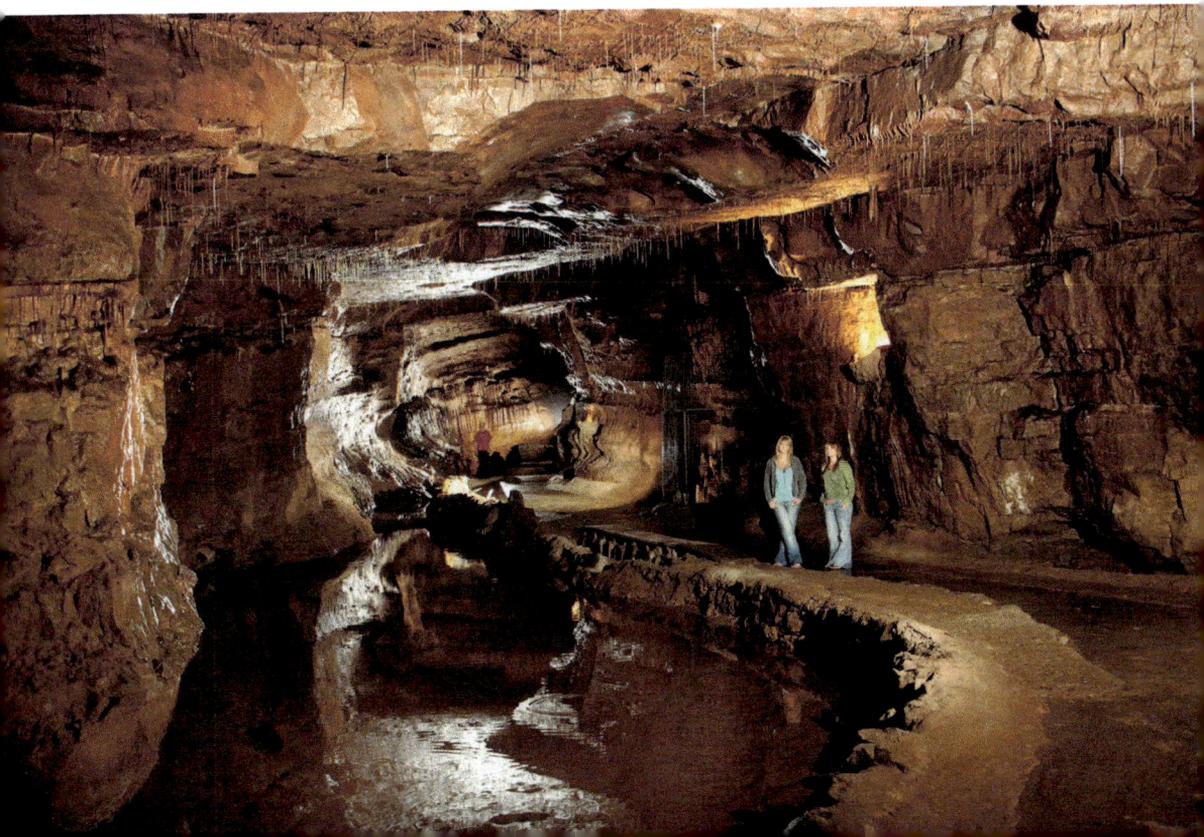

Soon, for a fee, they took curious visitors into the caves. Using candles to light the way, visitors were expected to wade or swim through icy water, climb underground cliffs, and slither across huge boulders covered in slimy mud.

The caves were finally opened to the public in 1939, just before the outbreak of war. They were requisitioned initially as an explosives store and then later as a place of safe keeping for artworks and important documents from Cardiff and Swansea, permanently protected by armed guards. It was not until 1964 that they reopened.

Today there is plenty here to keep children entertained. They have an opportunity to squeal at one of the world's largest collections of 200 life-sized model dinosaurs. There is a replica Iron Age fort and Dr Morgan's Victorian farm, a fossil house, Shire Horse Centre and playgrounds. You can, if you wish, get married here in this undeniably spectacular setting or bring your children to meet Father Christmas. It has obviously diversified to become a popular tourist attraction but the beauty of those memorable caves remains at the heart of the experience.

You suspect that there are still secrets waiting to be uncovered but it remains a dangerous place. Experienced cavers must be guided if they wish to explore the wild caves beyond the bright lights and the families enjoying time together.

The caves are at Abercrave, postcode SA9 1GJ.

Original photography by GeoPictures.net. (Nat Showcaves)

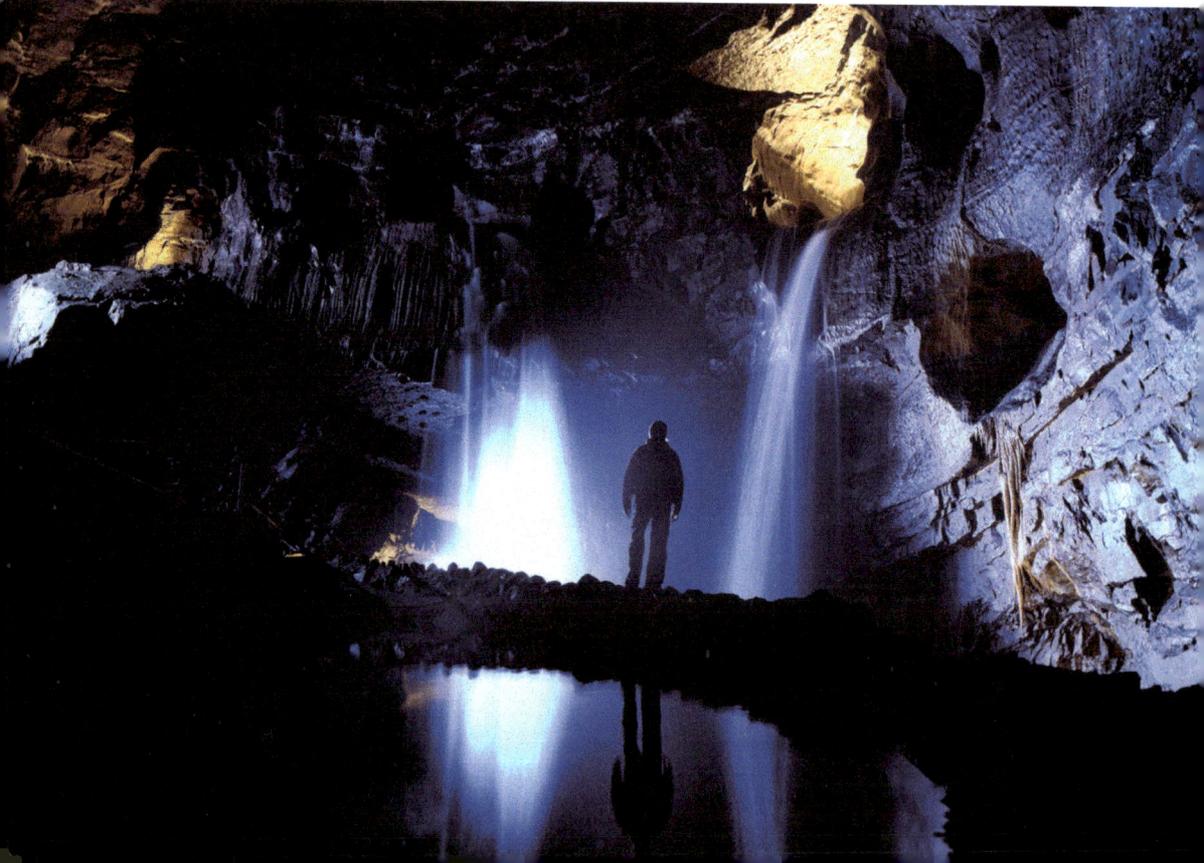